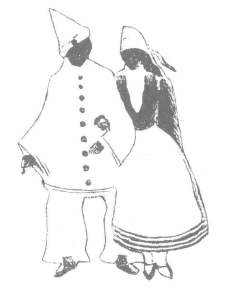

Cornelia Stabenow

Henri Rousseau

1844–1910

KÖLN LISBOA LONDON NEW YORK PARIS TOKYO

This book was printed on 100% chlorine-free
bleached paper in accordance with the TCF standard.

© 1994 Benedikt Taschen Verlag GmbH
Hohenzollernring 53, D-50672 Köln
Production: Beate Frosch, Cologne
Cover design: Angelika Muthesius, Cologne
Picture research: Frigga Finkentey, Cologne
Translation: Charity Scott Stokes

Printed in Germany
ISBN 3-8228-0552-1
GB

Contents

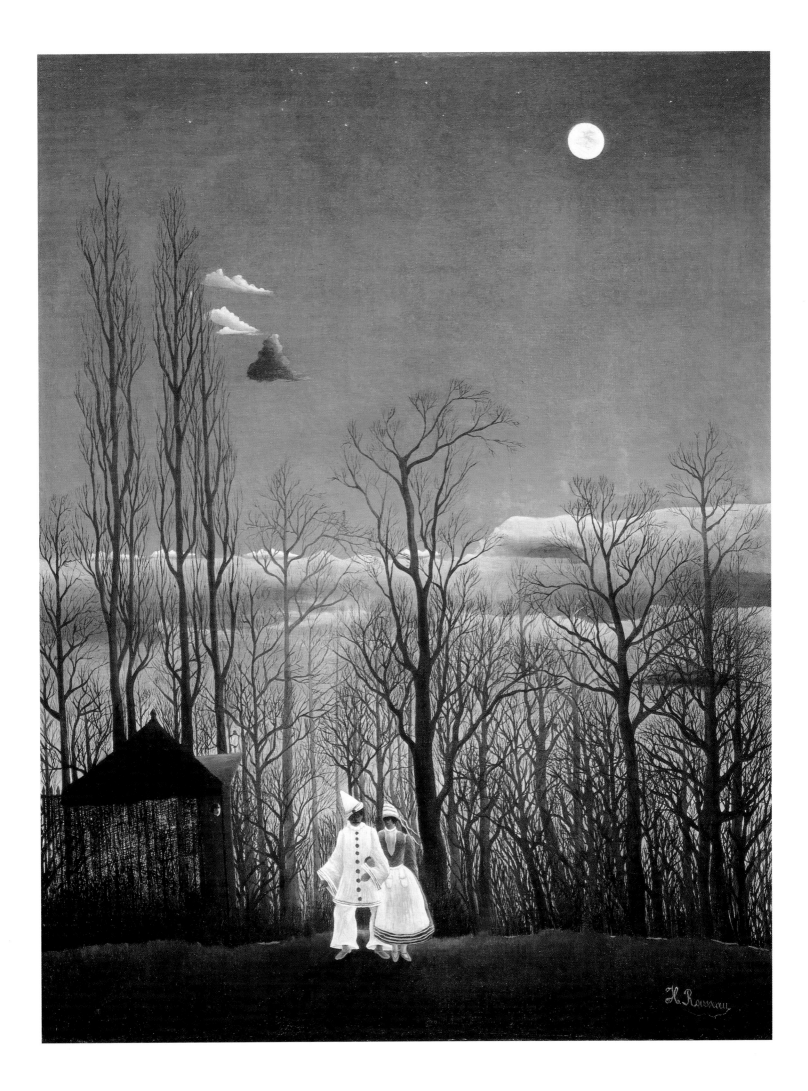

A Carnival Evening

On 18th August 1886 a spectacular exhibition opened its doors to the public, in the temporary premises of the Paris Post Office Headquarters on the Place du Carrousel. It was organised by the Société des Indépendants, a group of independent artists founded two years earlier by Georges Seurat, Paul Signac and others. Some fifty works were exhibited, all of which would have failed miserably in the eyes of the official Salon and would have scandalised even the small circle that supported Impressionist painting. The organisation was revolutionary in that there was no jury and no imposition of stylistic criteria. For a fee of fifteen francs any artist could participate, with or without academic training or aesthetic philosophy.

The exhibition took up Gustave Courbet's challenge and declared the field of art a democratic one, open to all comers. Two pictures caused a sensation: Georges Seurat's *Sunday Afternoon on the Ile La Grande Jatte,* a composition in contrasting sections of dotted primary and complementary colours, and the night scene, *A Carnival Evening* (see p. 6) by Henri Rousseau, the little toll collector whose contribution to the Salon des Refusés in 1885 had caused many viewers to laugh till they cried. Although some few critics were well-disposed and ascribed to both artists a spontaneity comparable to that of pre-Renaissance Italian art, sharp distinctions were drawn between the two. Seurat was seen as an intellectual, as the potential leader of a new movement and inventor of the pointillist technique which provided a scholarly response to the problems of Impressionism, Rousseau as an amusing innocent, who disregarded all the refinement of French painting and all the achievements of optical illusion. He demonstrated neither consciousness of the history of art nor the bracing experimentation of a modern daredevil but only the canvas itself – a surface on which he outlined and coloured with meticuluous care a white moon, clouds against the deep indigo of night, black tracery of bare trees, a transparent woodland pavilion and a couple in fancy dress, hovering like figures straight out of a Belle Epoque chocolate advertisement.

This puppet theatre on canvas is a key work, initiating as no other work could have done the mystical career of the Douanier and the pictorial anarchy of post-Impressionism. At the age of forty-one Henri Rousseau appeared upon the scene in just so surprising a manner as his harlequin. Undated, like his little figures, he held his place among the

"The whole visible universe is nothing but an accumulation of images and signs to which the creative imagination assigns a value and a place, a kind of food to be digested and transformed. All the capabilities of man's soul must be subordinated to the imagination, which makes claims on each one of them. "
Charles Baudelaire

A Carnival Evening, 1886
Un soir de carnaval
Oil on canvas, 106.9 x 89.3 cm
Philadelphia, Philadelphia Museum
of Art, Louis E. Stern Collection

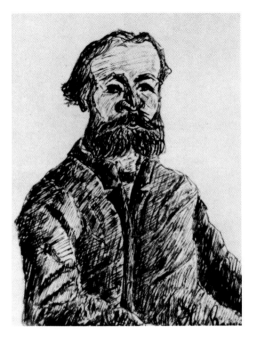

Self-portrait, 1895
Indian ink

avant-garde for twenty-five years alongside Paul Signac, Vincent van Gogh, Paul Gauguin, Henri Matisse and others. He was thought bizarre, an ambitious painter with the inadequate technique of a six-year-old. His pictures won acclaim as jokes. His works could be relied on to raise a laugh, even when they were hung in obscure places by the committee of the Indépendants, or when in 1907 Frantz Jourdan, president of the Autumn Salon, relegated them to the less prestigious section devoted to decorative arts. Rousseau gained a reputation gradually year by year, but it was a kind of *succès de scandale,* and some artists who were striving for new perceptions began to lose patience. It was only by appealing to an artist's agreed right to exhibit without the approval of a jury that Henri Toulouse-Lautrec was able to save Rousseau from exclusion by the Indépendants in 1893. The American Max Weber reported that his teacher Henri Matisse passed over any mention of Rousseau in frosty silence.

When at sixty-six Henri Rousseau died of blood-poisoning, he was listed in the Necker Hospital records as an alcoholic, but he at once became a legend, the "gentle Douanier", as Guillaume Apollinaire named him, the "angel of the night-life quarter" (Montparnasse). His is the simple and yet incredible story of an unworldly petit bourgeois who painted in an introverted, almost autistic manner. He himself cannot have been fully aware of what he was doing; he did not distinguish between his pictures and reality, and in art as in life remained gullible to the end. It is clear that, as he ceaselessly attracted public attention, such eccentrics of the fin de siècle as Alfred Jarry, Paul Gauguin and Guillaume Apollinaire saw him as a kind of talisman and living proof of the ideas with which they sought to combat bourgeois ignorance and blinkered values. It is no less clear that Rousseau played along with the intellectuals' game, as his first biographer, the German art critic and collector Wilhelm Uhde, surmised in 1911 and the historian Henry Certigny confirmed fifty years later; he shaped his own naive persona partly in self-defence and partly to gain the recognition he craved.

The following anecdote, though it may be apocryphal, is typical of Rousseau's muddled circumstances. As so often, his fellow artists thought up a practical joke at his expense; they sent him an invitation to a reception at the residence of the President of the Republic. On his return Rousseau told them that guards had prevented him from entering the building, that the President himself had come out and tapped him sympathetically on the shoulder, saying: "Too bad, Rousseau, that you are wearing everyday clothes. You see that everyone else is in evening dress. Come another time". Extravaganzas of this sort made the best of a bad job, but behind the good-humoured clown's mask there was another face.

In 1895 Rousseau presented to the publishers Gérard et Coutances a biographical notice and a self-portrait in pen and ink (see p. 8) as a contribution to the projected second volume of "Portraits of the Next Century". The drawing is of an apparently unremarkable old man, shabbily dressed, who turns to face the observer with faun-like features reminiscent of Paul Verlaine's. His eyes are in sharp contrast to the wearily sagging shoulders. His gaze is keenly perceptive but also mistrustful, fear-

ful, kind, manically ecstatic and introspective, alternating between tragedy and comedy, a physiognomy divided in two. At this time Rousseau was fifty-one years old, but the psychographic portrait matches the descriptions given by contemporaries such as Gustave Coquiot, Arsène Alexandre, Robert Delaunay, Wilhelm Uhde and even the police records of 1907.

Rousseau's dual personality made him at once kindly and childish, roguish and intolerably malevolent, and inscrutable to a degree that suggests an inner life of suffering. Indeed, his life resembled a game of hide-and-seek. He served as a toll collector for the City of Paris for twenty-two years before retiring early in 1893; he never commented on the fictitious inspector's title "Douanier" which the public bestowed on him. He encouraged the persistent legend that he had been a member of the overseas forces helping to bring about the coronation of the Hapsburg Maximilian of Austria in Mexico, and that he had saved the city of Dreux from civil unrest during the Franco-Prussian war. The fact is that at the time in question, in 1863, he was serving a juvenile sentence for stealing the paltry sum of twenty francs from his employer in Angers, the advocate Fillon, and for the duration of his voluntary military service with the 51st infantry regiment he stayed at home, far from any scene of battle.

He took every opportunity to mourn in public the death of his first wife Clémence, who died of tuberculosis in 1888 at the age of thirty-seven. On festive occasions he regularly played the waltz that he had composed for her during her lifetime. He hardly ever mentioned the deaths of four children of this marriage, or his daughter Julia, the only child to attain adulthood. When he was prosecuted in 1909 as accomplice to a certain Louis Sauvaget on a charge of embezzlement and forgery, and given a two-year suspended prison sentence and fined one hundred francs, he strove for recognition as a respectable citizen. He presented himself as a patriot, as "father of the poor", as honorary drawing teacher at the Association Philotechnique, a philanthropic institution for education of the people founded in 1848, and stressed his earlier role as father of the family, who had cared for the sick in addition to working a sixty-hour week. Above all he insisted on his pressing obligation to paint, and it was in this connection that he made a point which touches his life's deepest complexities: "If my parents had recognised my gift for painting . . . today I would have been the greatest and wealthiest painter in France." In the biographical notes of 1895 he had written: ". . . since his parents were not well-to-do, he was compelled at first to follow another path, rather than the one to which his artistic disposition inclined him. It was only in 1885 that he began to work as an artist, after many disappointments, alone, with no teacher except nature, and with occasional advice from Gérôme and Clément." These pronouncements suggest that throughout his life Rousseau suffered from a feeling of inferiority – afraid that without academic training he was bound to remain an amateur painter. The tendency to blame his parents was probably caused by the shock he experienced as the gifted nine-year-old son of a respected family of skilled craftsmen, merchants and officers, when his father lost all they possessed – three houses and a

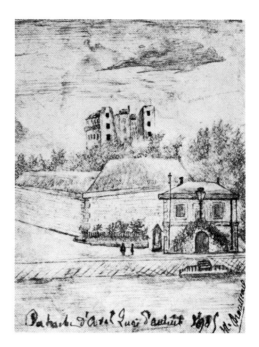

River Seine, Quai d'Auteuil, 1885
Patache d'arrêt, quai d'Auteuil
Pen and Indian ink on paper, 14.5 x 11 cm

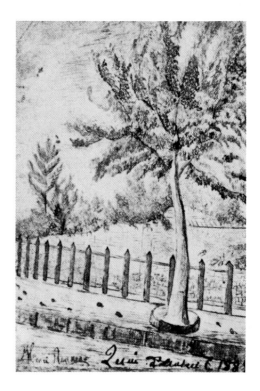

Quai d'Auteuil, 1885
Pen and Indian ink on paper, 16 x 10 cm

business – through speculation. The social decline of the parents had serious consequences for Rousseau. His schooling, with its poor results, his military service and his time as toll employee, promised no prospects. The only escape route lay in art, and he was encouraged in this direction by his Paris neighbour Felix-Auguste Clément, winner of the Prix de Rome, who had started from humble beginnings. Taking up the challenge, Rousseau found a way of offsetting all his dreams of material wealth and social recognition. In spite of the continual risk of mockery, he exploited every opportunity to rise out of anonymity. Alongside the intellectuals, the dandies, the provocateurs of his time, he divided his existence between the uninfluential milieu of the poor and the aggrandisement of the artist who knows how to turn each slight of fortune to his own advantage.

Part of the Rousseau legend lies in the obscurity of his beginnings as a painter. He repeatedly maintained that he did not pick up a brush until he was forty or forty-two, but in 1884 he had obtained a licence to copy in the state galleries, the Louvre, the Musée de Luxembourg and the palaces of Versailles and Saint-Germain-en-Laye, thanks to a recommendation submitted by the artist Clément to the Minister of Education, Armand Fallières. In 1886 he contributed to the Salon des Indépendants for the second time. The events of these years put him in the public eye, and must have been preceded by earlier attempts at painting, but it is impossible to reconstruct exact details since his manner of painting was soon imitated by others, and he was constantly re-working and re-dating earlier canvases.

The two hundred pencil and chalk drawings which have survived from the years up to 1895 are informative. They seem to be the work of a self-taught artist who would sketch his surroundings at work or undertake excursions outside the city in his leisure hours. The Quai d'Auteuil, one of the numerous Seine ports, and the city gates were among the locations where Rousseau inspected incoming supplies of wine, grain, milk, salt and methylated spirits, and issued passes. The two views of 1885 (see p. 9), which focus on a rural suburban idyll almost entirely without human figures, demonstrate the layman's exclusive interest in simple, visible reality. Rousseau was concerned to transfer to his canvas the three-dimensional configuration of tree and fence, toll house and tenement, with great care and without foreshortening. His purpose was to show things as they were commonly perceived, which meant that a fence must consist of a row of identifiable posts, while the foliage of a tree must comprise innumerable tiny elements. House, wall and reinforced river bank must give evidence of the building materials' texture and of the principles of construction, whereas clouds were to be seen as intangible silhouettes.

Since it was Rousseau's intention to match what he saw with the facts as he knew them, there was no cause for him to seek to impose the spatial rationality of linear perspective which had prevailed since the Renaissance. It was equally impossible for him to establish an individual style which lessened the importance of what he saw and knew to be the nature of things. Mysteriously, Rousseau must have been able to produce copies of pictures such as the Lion and Tiger painted by Eugène

Delacroix in 1828/29, since one was hung in the Ecole des Beaux-Arts retrospective in 1885. The moderately successful copy is accurate and professional in the use of materials and perspective, which suggests that the painter may have made a deliberate choice in not conforming to convention – a consideration which would make the so-called "naivité" of his art even more of an enigma. If there was a deliberate choice, then it was taken on intuitive rather than on theoretical grounds.

In the evening view of Ile Saint-Louis as seen from the Seine port of St Nicolas, today's Port du Louvre, the two-dimensional area of the picture prevails over the perspective of the left side (see p. 13). Painted by another hand, or by Rousseau copying from another picture, the cobbled and rutted quay with its navigator's hut and the shadow cast by the distant exciseman display a familiar concept of space, in which things are arranged according to distance and relative size as on a receding stage. By contrast, the cargoes unloaded on the quay, the barges, the iron architecture of the Pont des Arts, the houses and the Cathedral of Notre Dame on the island, all contribute to an effect of unfamiliar and mysterious density. Nothing is just itself. Cool blue-green transforms the piles of cargo veiled in tarpaulin into a gleaming moonscape of strange transparency. The piers of the bridge hover over the seemingly frozen river without supporting the structure above them. The lights reflected in the water take on an existence of their own, independent of the bright gas-lamps to which, by rights, they belong. The ships' masts with their little tricolor pennants reach upwards into the clear evening sky, in harmony with the Paris rooftops, chimneys and towers, but without spatial reference to the bridge. Liberated from the everyday bustle which Emile Zola's hero Claude Lantier experienced at this very spot, the metropolis becomes a picture of peace. Into this still life, the little exciseman Rousseau paints himself centre-stage, on the borders of day and night, of outer and inner reality, dreaming and keeping watch over his idea of beauty.

This tightrope walk between optical impression and visionary out-

come explains why both traditionalists and avant-garde agreed, albeit for different reasons, on the label "naive" for the creator of this magical other world. Both used the picture in their reflections on what was possible in the realm of painting, and on the historical development of aesthetic theory. In the face of such theorising it is indeed tempting to see Rousseau as the embodiment of the grass-roots artist unencumbered by cultural baggage. His interest is always directed immediately and impartially to the object before him. Method, style, his own distinctive mark are subordinated to his perceptions. His concern is with precision, with the meaningfulness of detail rightly observed.

Since he was no master of linear perspective, and yet desired to convey the familiar illusion of space, the objects painted in the View of the Ile Saint-Louis undergo an involuntary planar transformation. Lacking central focus, the individual items are aligned with equal prominence alongside one another. The flat surface itself begins to take effect as an

View of the Ile Saint-Louis seen from Port Saint-Nicolas, 1888
Vue de l'Ile Saint-Louis prise du port Saint-Nicolas
Oil on canvas, 46 x 55 cm
Tokyo, Setagaya Art Museum

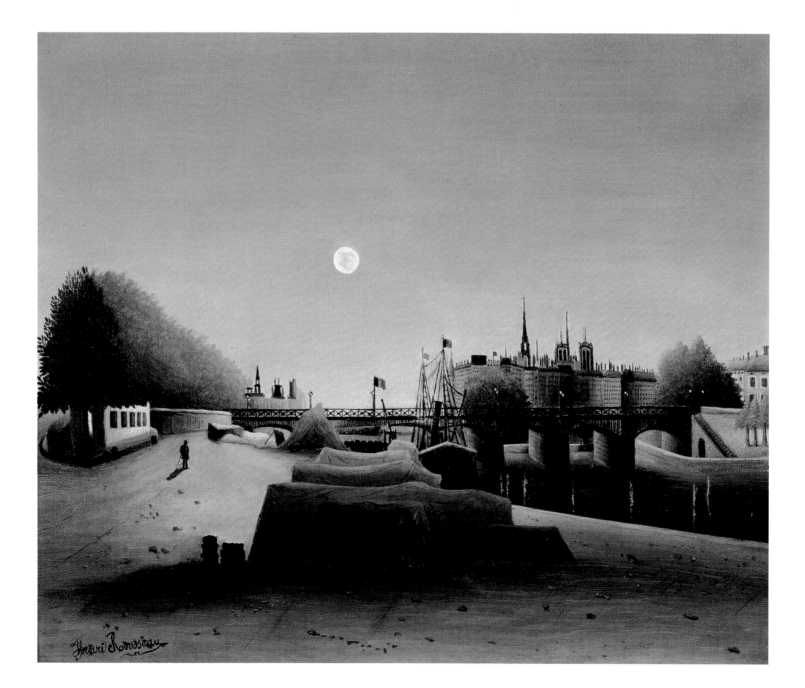

elementary system of axes and diagonals. The carefully linked crosswise ornamentation of the bridge's balustrade introduces a strong horizontal element into the composition, which is balanced by the many vertical lines of towers, funnels and masts. Intuitively the Douanier ceases to "open a window on reality" and paints his way into the tradition of surface and segment. Camille Pissarro, who with Odilon Redon was one of the first to admire the artist, attached great value to this spontaneous creativity, which, in his opinion, replaced studied technique by true feeling.

An early peak of intuitive achievement was the highly unusual *Toll Station* (see p. 15), usually dated 1890. With this unspectacular view of what was simple and close at hand, Rousseau celebrated his workplace, one of the numerous toll stations on the fortified city wall extended under Louis the Sixteenth. There is a similar photograph taken by Eugène Atget (see p. 14): midday rest has settled on the border between city and country, where one seems to merge into the other. There is no trace of the hectic metropolis behind the hills. The gates are open, but time seems to stand still. The toll collectors doze at their posts, fixed to the spot, immobile as the lamps.

Rousseau himself conceded that his superiors in the toll service gave him an easy time so that he could work better; the still life structure reflects these circumstances. The responsible and yet ridiculous position of the little official who becomes for an instant all-important consists for the most part of sitting and waiting in readiness. Driven in this way to meditation and self-forgetfulness, Rousseau became absorbed in the beauty of his surroundings. The gate stands strangely without function amidst the greenery which is interrupted only by the buildings of brickyard and village. The brick wall rises, railings, cypresses and chimneys are aligned, while all else is submerged in glimmering foliage as under the eye of a new Vermeer. In this timeless setting the inspection of the

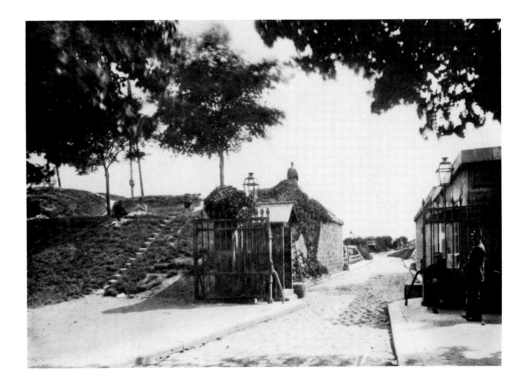

Eugène Atget
Toll Station Porte de Vanves
L'octroi de la porte de Vanves
Photograph
Paris, Musée Carnavalet

14

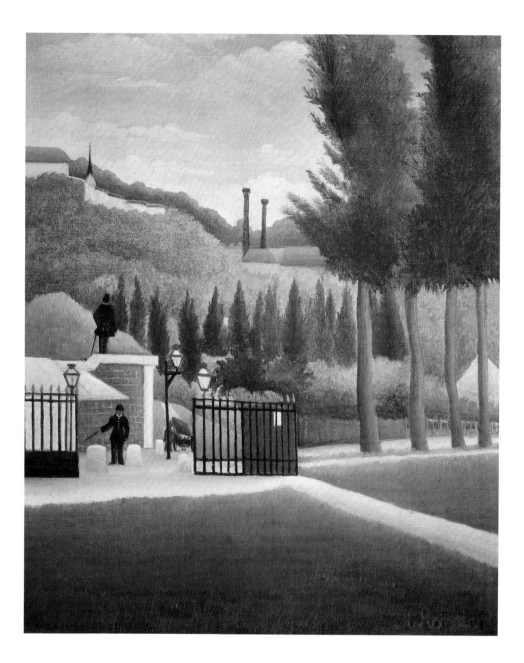

Toll Station, 1890
L'octroi
Oil on canvas, 37.5 x 32.5 cm
London, The Courtauld Institute

vehicle loses prime significance. Imperceptibly the border idyll is transformed into a dream of the world's edge. The paved road is replaced by grass and narrow footpaths, denying access to the gate.

This picture, small in format, is a further key work. It contains the barrier motif, sign of twenty-two exhausting years of service, determining the whole course of Rousseau's life, a metaphor of the tightrope-walker's power and lack of power. Formally the picture yields an astonishing synthesis between pure perception, a preoccupation of the Impressionists. and the flat constructed surface sought by the post-Impressionists. The light green suggests air and vibrant light, but without actual realisation of either, since the entire canvas is taken up with the thick and flat application of paint. The landscape presupposes precise observation of nature, without concessions to the fleeting moment. Like Seurat, and like Gauguin and the Pont-Aven circle, Rousseau derived from visible reality the principles of densely balanced composition reaching to the very edges of the picture. The tree becomes an element of design, matching the structure of fence and railings. For the

The Walk in the Forest, about 1886
La promenade dans la forêt
Oil on canvas, 70 x 60.5 cm
Zurich, Kunsthaus Zürich

sake of balance the artist "discovers" a white window in the wall and puts the areas of sky and grass in proportion to one another. Every detail is an essential part of the composition. Yet this totality is achieved without the imposition of a rigid system, since Rousseau lets his perception of the object determine his manner of painting – dotted, planar or linear. Unlike other artists of the time, notably Cézanne, who was only five years his senior, Rousseau did not attach prime importance to method; rather he allowed several forms of expression to co-exist in a single picture, and let what he saw become the determining factor. His thinking followed the rules of two-dimensional composition with ease, which helped him to persevere and to achieve consistency, as did his readiness to accept the advice of the Salon painters Felix-Auguste Clément and Jean-Léon Gérôme, namely that he should let nature be his only teacher. He painted what he saw, the way he saw it, undisturbed by nagging intellectual doubts or aims.

The upright seriousness with which Rousseau regarded visible reality and followed the leadings of his heart, for instance in the subjective portrait of his first wife Clémence (see p. 17), could irritate his consciously modern contemporaries. In 1909 the art critic Arsène Alexandre wrote in the journal "Comoedia": "With will alone the good Douanier Rousseau could not have done it. If this touching allegory had been intended, if these forms and colours had been derived from a coolly calculated system, he would be the most dangerous of men, whereas he is surely the most honest and upright. . ." These words remain an apt indication of the fascination exerted by an artist who by following his natural disposition "naively" achieved intuitive compositions that an artist given to theory could have achieved only by means of great labour, having first to escape the trammels of rational thought.

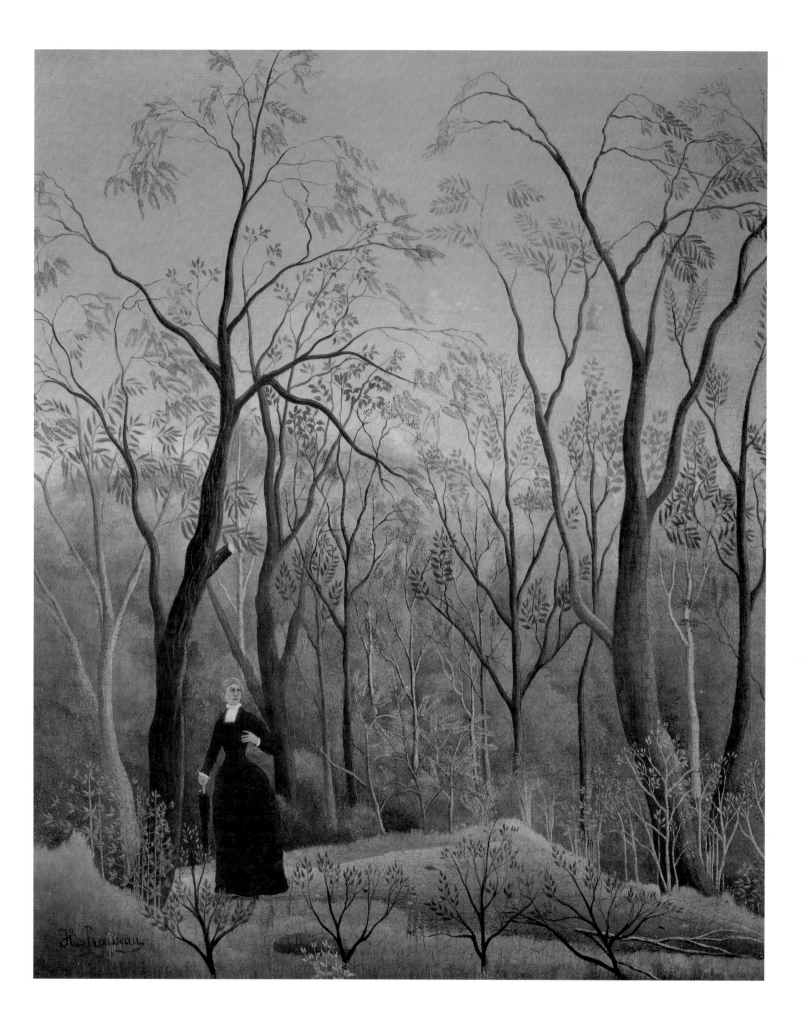

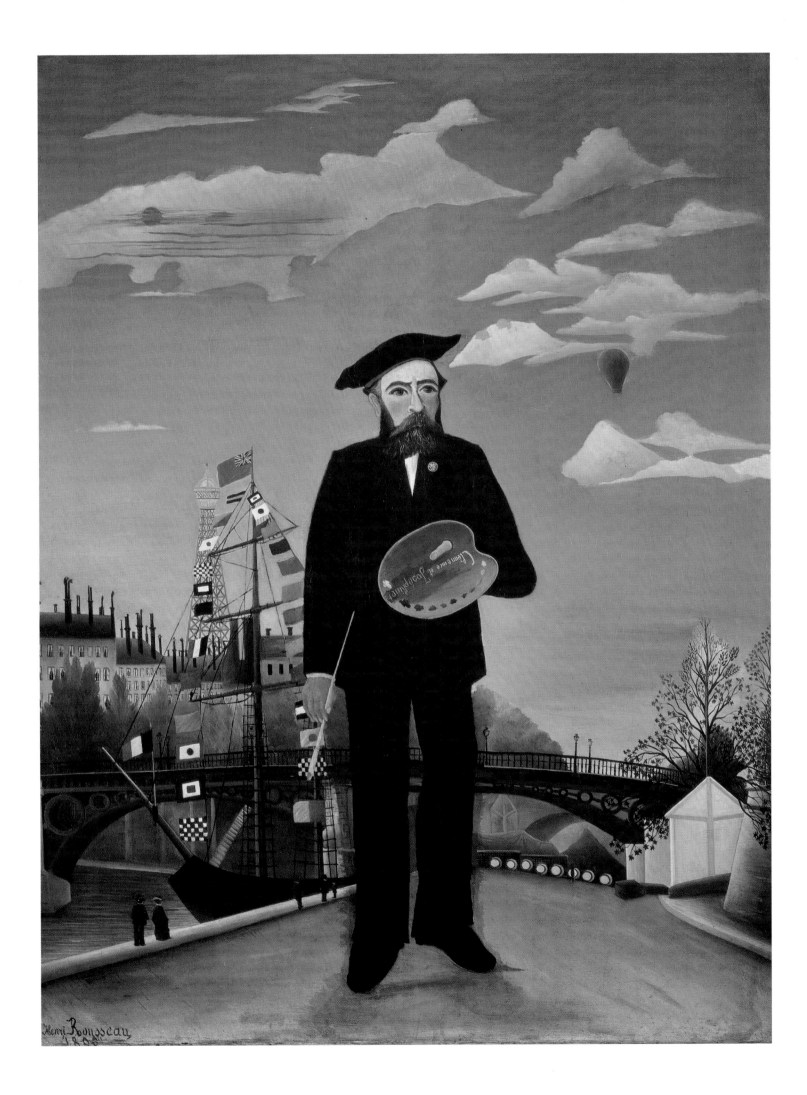

The Liberty of Art

Pablo Picasso, who got to know the Douanier's painting by 1908 at the latest, but most probably around 1905, is reported as saying: "There is nothing odd about Rousseau. He is the most perfect representation of a distinctive and immutable logic". This opinion is in marked contrast to the still prevailing view of Rousseau's naiveté as a consequence of lack of professional skill.

The picture *Myself. Portrait-Landscape* of 1890 (see p. 18), which was important to Apollinaire's circle, to Robert Delaunay and to the Dada movement in Berlin, may be seen as a clear statement that the "genius of the people" was not inclined to make concessions to optical conventions. Without regard to the surrounding minutiae Rousseau positions his own superdimensional figure centre-stage, in the middle of his painting as of his world. Again he chooses the port of St Nicolas, but this time his back is turned to the Pont du Carrousel. This posture and the size of the figure are vital to the interpretation of the picture. Three years before his voluntary retirement the forty-six-year-old Douanier was making an unmistakable declaration of his dedication to art. Figuratively and factually he was leaving behind him the cargoes that had to be inspected every day, to take up his position on an imaginary axis stretching from the Louvre to the Ecole des Beaux-Arts, rising up so high into the sky that he outgrows the Eiffel Tower and nears the balloon in its ascent.

There is a deliberate renunciation of perspective. The smallest details and the dominant colour, black, serve to emphasise Rousseau's claim to be a painter of the first rank. Within this framework, at least, he is determined to make his dream of success and social ascent come true – he, who would like to be "the greatest and wealthiest painter in France", who towards the end of his life, in 1907, still yearned for eventual fame and recognition not only in France but also further afield. In a spirit of patriotism he includes in his picture two emblems of technical achievement in France, the hot-air balloon and the Eiffel Tower, the controversial world wonder of 1889 that only Seurat had thematicized before him, in the previous year.

These two motifs function as heroic attributes for the central figure, which in the original design was even larger. The series of national flags – most of them freely invented, except for the tricolor and the Union Jack – create in the background a kind of garland for the painter, with

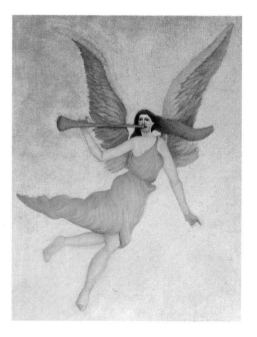

Liberty inviting the Artists to take part in the 22nd Exhibition of the Artistes Indépendants (see p. 23), detail

Myself. Portrait-Landscape, 1890
Moi-Même, Portrait-Paysage
Oil on canvas, 143 x 110 cm
Prague, Národni Gallery

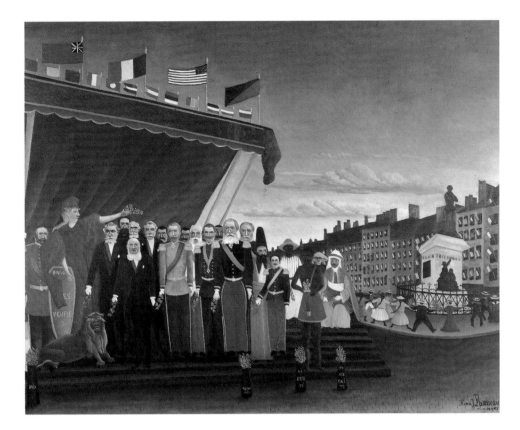

The Representatives of Foreign Powers coming to salute the Republic as a Token of Peace, 1907
Les représentants des puissances étrangères venant saluer la République en signe de paix
Oil on canvas, 130 x 161 cm
Paris, Musée du Louvre, Picasso Foundation

the promise of international esteem. Clothed in dignified black, he hovers in collage style in the world of his imagination which matches precisely the townscape of Paris. So concrete is his notion of the icon-like self-portrait, reminiscent of the notions of late mediaeval artists, that he updates it autobiographically over the years. On the artist's palette one may see written the name of his wife Clémence, who died in 1888. Alongside it there appears the name of his second wife Joséphine, whom he married in 1899. In 1905 he decorates his lapel with the "Palmes académiques", an honour received in error. When this work was exhibited in the Salon des Indépendants, Paul Gauguin, tired of pointillism, allegedly exclaimed: "There is truth . . . there is the future . . . there is the very essence of painting!" In this picture Rousseau indeed achieves a remarkable synthesis of form and colour which defines in its own terms the modern style as planar juxtaposition in all its purity. Moreover, he makes radical use of black, which had been banned since Impressionist times, and in so doing he clearly rejects optical illusion. Most surprisingly of all, in making a familiar object into an autonomous element within the picture he is a forerunner of Pop Art. He entrusts to the brush of his alter ego the red with which his own hand has painted the flags on the canvas.

The proud inventor of the Portrait-Landscape maintained a dogged and uncompromising stance towards the public, and it is not only in his dreams and desires that an explanation is to be found. Behind the self-portrait, and behind many of his other works, lies an avowal of faith in the French Revolution, which includes an element of sentimental nationalism.

The picture *A Centenary of Independence* of 1892 (see p. 21) cel-

ebrates the people's dream of Liberty, Equality and Fraternity which the Eiffel Tower and the Paris World Exhibition of 1889 had made visible far and wide. The composition reflects the ideology of the Third Republic, intent on consigning to oblivion the crises of 1870/71 – the defeat by Prussia and the bloody civil strife of occupied France and the Paris Commune. The profession of faith in the proclamation of human rights was repeated emphatically in the painting *The Representatives of Foreign Powers coming to salute the Republic as a Token of Peace* of 1907 (see p. 20). The vividly coloured group portrait has as its theme the union of all peoples and worldwide peace in society. On the platform the painter brings together the heads of state of the European monarchies and the Emperor of Ethiopia, the Czar and the Shah of Persia, all of whom have come to pay homage to the Republic. Rousseau presents himself as the most patriotic of patriots, and does not forget the six presidents of the Third Republic or the representatives of the four colonies of Madagascar, Equatorial Africa, Indochina and North Africa. The ring of dancers in the background is a variation on the dance motif familiar from the earlier *Centenary of Independence* and it draws attention to the memorial to the free-thinker Etienne Dolet (1509–1546), which was dedicated to the City of Paris as a symbol of freedom of opinion.

These two pictures, which provoked inordinate laughter, are testimony to Rousseau's republican views. He is also said to have been a freemason, a pacifist and – like many an urban petit bourgeois – an adherent of revolutionary movements. Pride in the political role of the people and a desire for democratic equality for the benefit of all determined his thinking and provide clues to many puzzles. Both these pictures, and the self-portrait, reflect something of the ambience of the Paris World Exhibition of 1889, an unprecedented apotheosis of peace and progress undertaken under the auspices of the French nation. Rousseau's lifelong love of new technology and of the brilliant colouring of flags, uniforms and costumes, in which red and black were prominent, will have led him to share the euphoria of the French politician and philosopher Jules Simon: "Here there are no more disputes between political philosophies and nations, we are all citizens of the Eiffel Tower!" Moreover, both pictures were conceived with a view to obtaining public commissions. In 1893 Rousseau submitted a landscape and a second version of A *Centenary of Independence* to the competition for the town hall in Bagnolet.

Yet political allegory is not all that the Douanier is striving for in these compositions. He is declaring himself a republican in art. In his autobiographical notes he demands "full creative freedom for the artist whose inspiration is for the beautiful and the good", and these pictures are ample evidence of his refusal to conform. In the self-portrait he entirely ignores the familiar in order to develop further his montage technique. He draws on sources from popular culture of the time. The ring of dancers in *A Centenary of Independence* is copied, presumably by means of a pantograph, from an illustration in the "Petit Journal" (see p. 21). The likenesses in *The Representatives of Foreign Powers* are taken from an almanac and combined with uniforms to create stiff

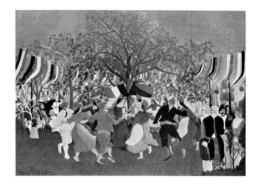

A Centenary of Independence, 1892
Le centenaire de l'indépendance
Oil on canvas, 112 x 156.5 cm
Private collection

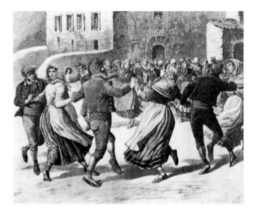

Fortuné Méaulle
The Farandole
La farandole
Woodcut
from: Petit Journal, 11 April 1891

figures reminiscent of fairground or photomontage dummies. The template-style application of local colour isolates one item from another, rather in the manner of pre-Renaissance painting, and creates an array of figures without perspective, two-dimensional, almost abstract. The narrative motifs become structural components. The added details give these scenes a rhythmic sense of joyful ornamentation, matching on a large scale the patterns on the little flags. The pictures take on the quality of a frozen rainbow. They anticipate the placard-style trivia of collage artists such as Max Ernst.

With his colour puzzle of 1892 Rousseau entered into competition with the intellectual avant-garde, which is indicative not only of his ambition but also of the self-assurance that he, the lay painter, had by that time acquired. He drew sustenance from praise ostensibly accorded him by Puvis de Chavannes (though possibly the visitor was Paul Gauguin in disguise): "Mr. Rousseau, as a rule I do not think highly of the gaudy colours favoured here by the Indépendants, but yours I like very much because they are right." Rousseau concluded: "He was thinking of my 'Centenary of Independence'. In the paper lanterns alone there were sixty-two different tones."

To paint in the right way – later he was to use the term "upright" – was the Douanier's aim. Was he unwittingly naive, because there can be no external criterion of rightness in art? Or was he concerned to paint pictures that were understood, an endeavour in which the formal experiments of the time had no place? In the latter case he could be seen as a painter who followed the traditions of popular folk art by conviction. There is some truth in both propositions. The claims made in 1890 were still valid in 1906 when Rousseau painted his ambitious work *Liberty inviting the Artists to take part in the 22nd Exhibition of the Artists Indépendants* (see p. 23). The democratic message expressed in the picture's serial structure, with an accompanying note of pride in the City of Paris, is an invitation to peoples of all nations to join together in free creativity, almost in the sense of Joseph Beuys' slogan "Every man is an artist". The Lion of Belfort promises victory to all those who, like Valton, Carrière, Willette, Luce, Seurat, Signac, Ortiz, Pissarro, Jaudin and Rousseau, take up the cry for freedom of creation. The allegory of Liberty hovering in the sky seems to be modelled on Coysevox's monument to Glory in the Tuileries. Beneath the city flag in the colours, as it happens, of the Salon des Indépendants, Rousseau shakes hands with founder-member Signac. Something of the revolutionary spirit of the bloodily quelled Commune of 1871 is still in evidence among the Indépendants. Rousseau showed his work regularly at the Salon, with the exception only of the years 1899 and 1900, but for others, too, this association of artists was the best and the most legitimate because it accorded equal rights to everyone. It was not long before the Salon was flooded by lay painters. Nor was it possible much beyond 1890 for the French government to ignore the activities of this liberal forum, of which the original and truly amazing Douanier was a worthy representative.

"Glorious painter of the Republic's spirit, The proud Indépendants hail your name as their banner."

Guillaume Apollinaire

Liberty inviting the Artists to take part in the 22nd Exhibition of the Artistes Indépendants, 1906
La Liberté invitant les artistes à prendre part à la 22ᵉ exposition des Indépendants
Oil on canvas, 175 x 118 cm
Tokyo, National Museum of Modern Art

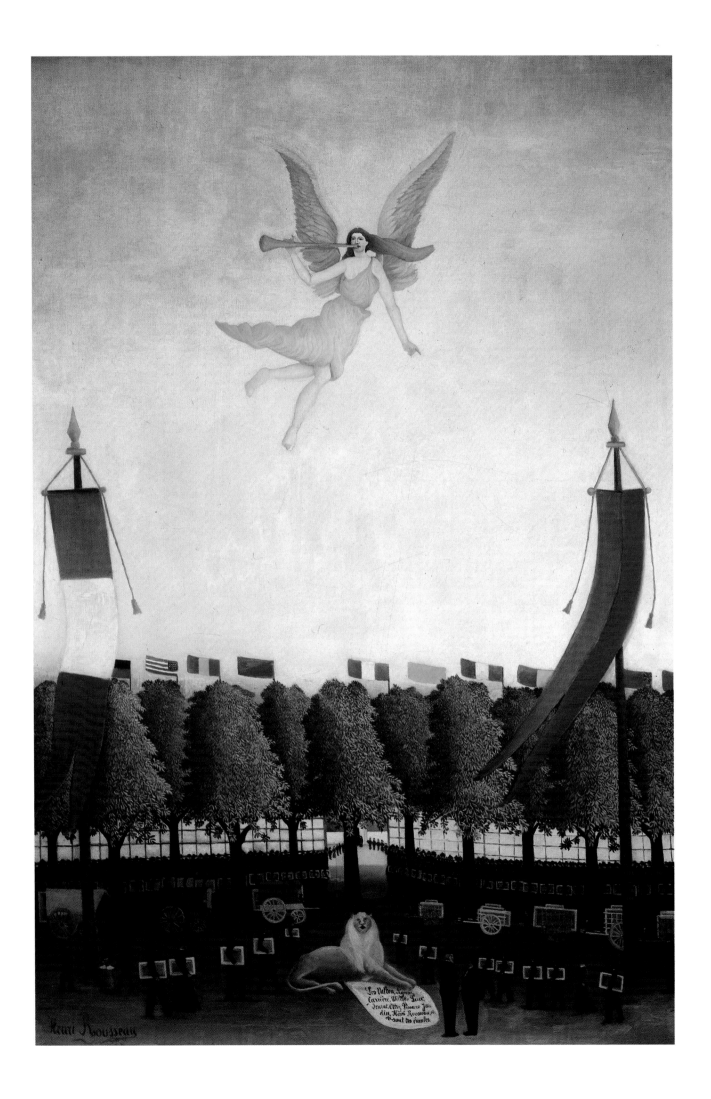

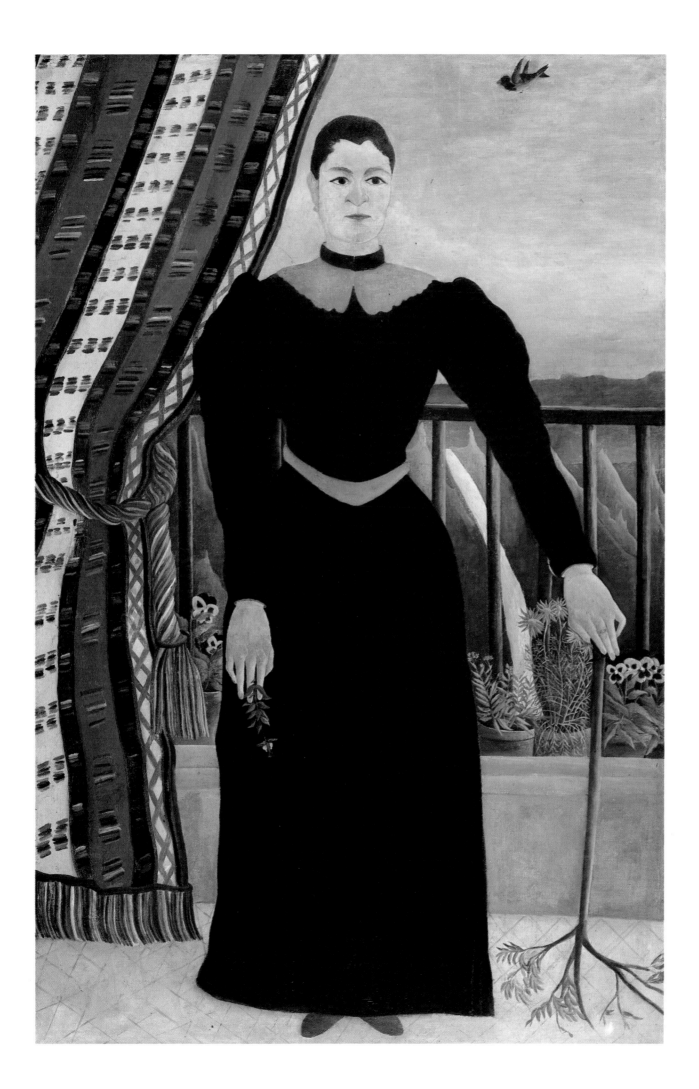

Poetry of Poverty

Throughout his life Rousseau tried to conceal his private circumstances behind the mantle of the artist, beneath the surface of his pictures. Yet the photograph taken of him in his studio about 1908 (see p.95) reveals much: the restrictions imposed by poverty, in spite of late financial rewards; the isolation of the outsider who yearned for bourgeois security and yet had nothing to call his own except his painting, which enabled him to forget his bleak surroundings. In the centre is his violin, with which, from time to time, he eked out his little pension of 1019 francs as a street musician; and with which he also entertained his guests at the soirées in this studio from 1907 onwards (see chapter 7). Here the glittering world of the cabarets and cafés of the Belle Epoque is not to be found. It is a far cry from the superabundance on which Rousseau's near-contemporary, Auguste Renoir, could draw. Everything that Rousseau undertook, as a painter, as composer of the Clémence Waltz and as a playwright, reflected in some sense the reduced circumstances in which he lived.

About 1890 he painted the *Flowers of Poetry* (see p. 28). Grass and garden take up the popular friendship cult expressed in the verses and garlands of albums and cards at the turn of the century. Meticulous as a botanist, taking pains over the smallest detail, Rousseau aligned his plants in a single plane. The red curtain and the clear blue sky transpose the poor man's bouquet to a reality in which the humble table becomes a balustrade and there are no confining walls. The rigorously frontal pattern is reminiscent of the millefleurs weaving that he may well have seen during his youth in Angers, and perhaps even have copied in Paris in the Musée de Cluny. The two-dimensional structure without air or light gives the still life a contemplative quality. Taking a close look at what is apparently without value, Rousseau celebrates the kitchen lyric and at the same time his own ideals, at one with the ideal of nature.

In an interview with the critic Arsène Alexandre given in 1910 he commented: "Nothing makes me so happy as to observe nature and to paint what I see. Just imagine, when I go out into the countryside and see the sun and the green and everything flowering, I say to myself, 'Yes indeed, all that belongs to me!'" More even than Rousseau's desire for social recognition, this avowal leads to the very centre of his creativity. The sequence of twelve still-life flower pictures which have come to light so far (see pp. 27–29) explains very clearly why the Douanier at-

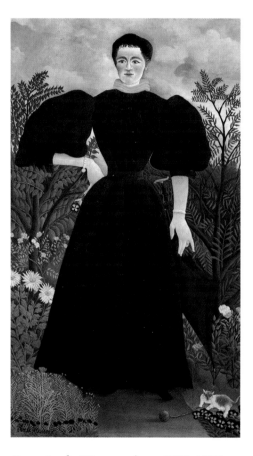

Portrait of a Woman, about 1895–1897
Portrait de femme
Oil on canvas, 198 x 115 cm
Paris, Musée d'Orsay,
Galerie du Jeu de Paume

Portrait of a Woman, about 1895
Portrait de femme
Oil on canvas, 160 x 105 cm
Paris, Musée du Louvre, Picasso
Foundation

tached prime importance to the object and not to the process of painting as did, for instance, Edouard Manet and Odilon Redon. For him the object, in this case the plant, embodies the portion of beauty and happiness that he finds outside and must encapsulate within his four walls as a protection against drab constraints. He makes a fetish of the open countryside, of public parks and gardens; brush and paint promise him part-ownership. Dispossessed, he paints into his pictures what should by rights be his. This motivation sets Rousseau apart from those artists who laboured to convey an illusion or a notion. Like the painters of the fifteenth century, he was at pains to take possession of reality; painting is a tool. All means serve to emphasise the concrete closeness of the object. Each form is observed individually, given precise delimitations and spread out frontally – planted, as it were, in the picture.

The painter proceeds as if he were a collector, sorting the flowers according to species and colour groups, arranging them decoratively in a vase which he always places in the central axis of the composition. Nothing is left to chance. At no time is the viewpoint of the observer taken into consideration. The horizontal table-top, the folds of the curtain, the fluting of the vase, the forget-me-nots, pansies, dahlias and mimosa aligned in a single plane, all draw attention to themselves only, creating something clear and static for the observer to behold. The apparent lack of individual characteristics and the neglect of space relations make the still life look at first like an impersonal stereotype. Symmetry, addition, enumeration are the regulating factors. The resulting bouquet provides an inventory of reality. So resolute is Rousseau's treatment of each detail that it almost seems possible to dismantle the flower arrangement. It is the montage principle itself that resolves the sense of transience. Each tiny detail asserts itself as an independent object, only identifying itself with the concrete surface of the picture. The shimmering light of the Impressionists is replaced by the structure of the object, which conjures up a magic counter-world. The familiar becomes strange; the pot with flowers in it hovers before coloured squares; the table is a band of colour; the curtain turns into an imaginary wall; external reality is less real than the picture; beauty becomes an everlasting possession.

It is significant that the still lifes, usually painted in thick layers, are considered to be the most clearly intuitive of Rousseau's works. No ambitious claims are imposed; the simple object, by contrast with the major themes, belongs to an intimate sphere. The tension between aim and achievement, often an essential consideration in lay painting, is no longer a concern. One with the possibilities at his disposal, free from problems of representation, Rousseau develops a rigorous planar structure which declares the picture unequivocally to be a flat surface. His naiveté, his unbiassed and unencumbered rendering of the object perceived, can be regarded as a style in itself. Every detail is executed with such concentration that it takes on an independent existence as an ingredient of pure form. The object becomes an element in the composition, a sign. Playfully and energetically Rousseau assembles his signs. He has a basic flower still-life scheme, on which he creates new variations, achieving a near-abstract effect by denying precedence to the theme and

Flowers in a Vase, 1909
Bouquet de fleurs
Oil on canvas, 45.4 x 32.7 cm
Buffalo (N.Y.), Albright-Knox Art
Gallery

26

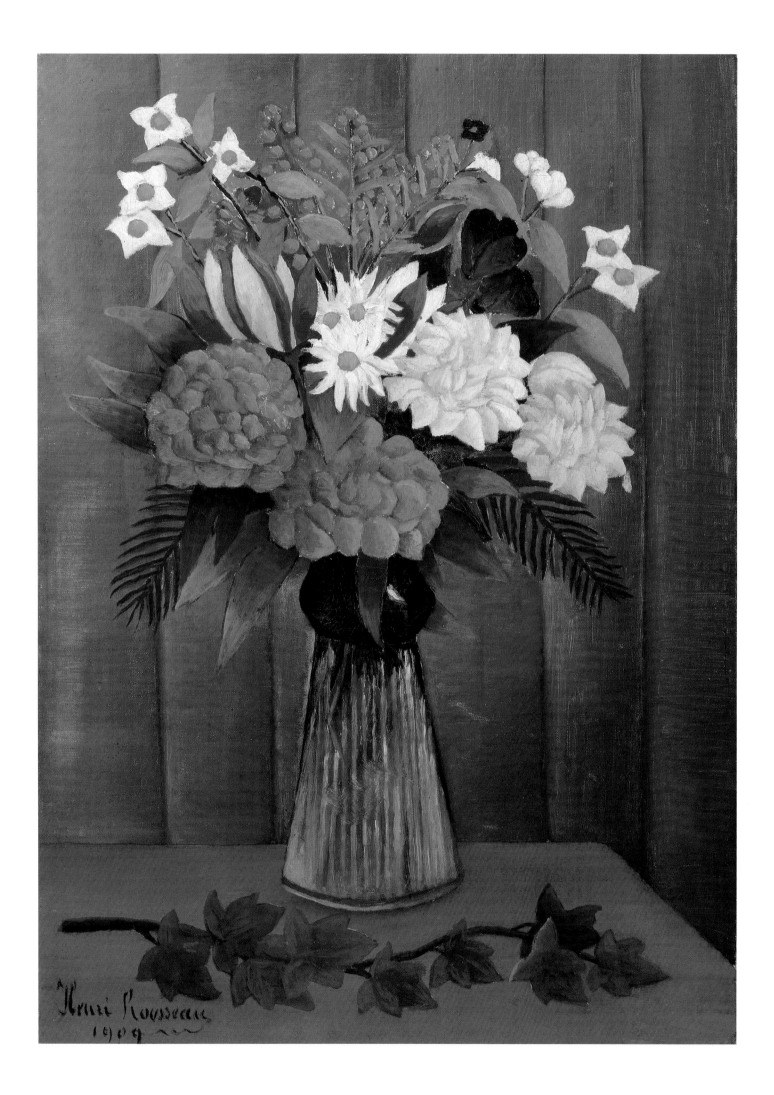

placing the balance of colour-shapes in the foreground. At the same time, the variations extend exploration to the boundaries of the imagination. The beauty of nature becomes increasingly important to the artist; towards 1910 it takes on strange, exotic features, which are manifested in the jungle pictures of his last years.

Rousseau attached particular importance to these still lifes, which were remarkable even in the context of post-Impressionism. Flower watercolours, painted swiftly and decoratively, have survived from his time as teacher at the Association Philotechnique. He shows a routine which is not in the least naive, demonstrating clear awareness of the difference between china-painting and the inventive experiments in form which are his very own. Moreover, there is no contradiction between the construction of nature as the quintessence of beauty and the wish for symbolic ornamentation of a theme.

Around 1895 Rousseau painted two pictures of women (see p. 24 and p. 25) which belong to the sequence of portrait-landscapes although they were commissioned works. For both pictures the painter made only slight alterations to the basic scheme of his self-portrait of 1890. He surrounded the dark silhouette of the figure with motifs indicative of the subject's life. In each case the milieu makes itself felt: the respectable suburban life of the petite bourgeoise on the balcony, the elegant world of the lady walking in the park. Since the figures are almost life-size, however, their surroundings take on a more strongly allegorical character, as if Rousseau would like to celebrate womankind, to find in close proximity the fulfilment of his yearnings for security and beauty. In his eyes, it is woman who tends the garden, embodying

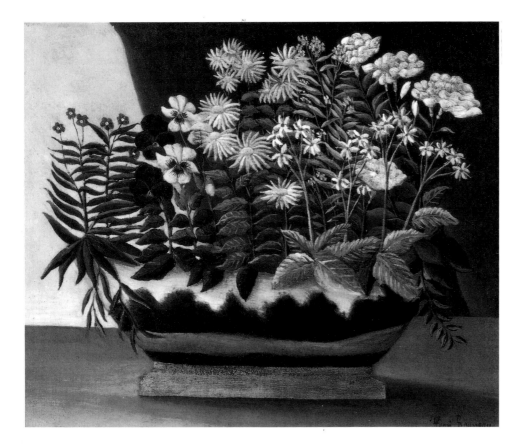

Flowers of Poetry, about 1890
Fleurs de poète
Oil on canvas, 38 x 46 cm
Upperville (Va.), Mr. and Mrs. Paul Mellon Collection

Flowers, 1895-1900
Fleurs
Oil on canvas, 61 x 50.2 cm
London, The Tate Gallery

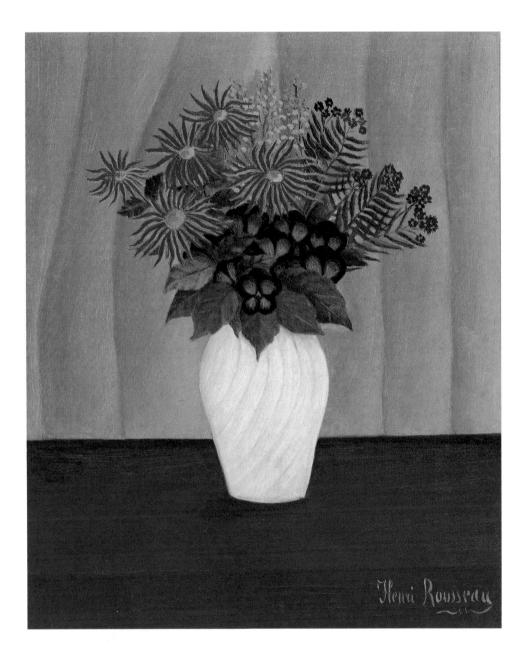

union with nature. With flowers planted carefully in pots she creates a barrier to protect the peace of the home against the barren hills outside, probably a representation of the fortifications around Paris, and yet extraordinarily reminiscent of the background to Leonardo da Vinci's *Mona Lisa* or *Madonna of the Grotto* . The colourful flowerbeds in the park become an extension of domestic peace, transforming the world outside into an earthly paradise.

Autobiographical importance has been attached to both pictures. The portrait of the woman on the balcony – purchased by Picasso in 1908 from Père Soulié – has been said to represent Rousseau's early love, the Polish woman Yadwigha who appears in his play "The Vengeance of a Russian Orphan" and in the jungle picture *The Dream* . The lady with puff sleeves and umbrella is supposed to be his first wife, Clémence. It is striking that the first picture has a bird and a broken bough as attributes instead of a conventional surround, which might indeed be taken to suggest a lost love. Behind both pictures there seem to lie Rousseau's poverty and his loneliness as a widower. After his wife

Clémence's death in 1888 he tried to fill the emptiness by leading a bohemian life and engaging in diverse love affairs. From 1893 he lived with Gabrielle, an officer's daughter. In 1894 he relinquished his eighteen-year-old daughter Julia to relatives in Angers; she was no longer willing to share her father's dubious milieu. He wanted to protect her against the tuberculosis which had sent his wife and four children to their graves. In the portraits, as in the still lifes, he banished this everyday world of misery and disease, and paid homage to an unproblematic reality, poetically exalted. All the magnificence that his art could conjure he put into the ornate curtain, the hands overdrawn in Gothic style and the figures themselves, intent on competing with the classic coolness of masters such as Ingres.

In the two portrait-landscapes Rousseau indulges his penchant for allegory only in minor motifs such as the plucked pansies, but other pictures are more patently symbolic. The relatively simple composition *The Present and the Past* (see p. 94) is dated 1899, but partial overpainting suggests that it could have originated as early as 1890. Dora Vallier makes this suggestion in her catalogue raisonné. If that is the case, Rousseau would first have painted this picture as a tribute to his beloved wife Clémence and then brought it up to date on the occasion of his marriage to Joséphine-Rosalie Nourry, widow of one Le Tensorer. It would, however, be a mistake to interpret the basic scheme of the picture as indicative of an earlier phase of Rousseau's work, since his compositions were occasioned by events, not shaped by formal considerations. The rather prim portrait of the *Girl in Pink* is less successful stylistically than the two earlier paintings of women. It has been shown to date from 1907, although it used to be dated earlier, and it portrays Charlotte Papouin, the sister of Rousseau's Breton god-child.

It has been said that the Douanier did not produce the intensity of his ambitious exhibited works when he undertook private commissions unless a commensurate fee was forthcoming. This cannot be said of *The Present and the Past*. The occasion was a personal one, perhaps requiring the fifty-five-year-old bridegroom to provide moral justification for himself. He entwined himself and Joséphine, whom he married on 2nd September 1899, with clinging plants, seemingly in repetition of Henri's avowal in "The Vengeance of the Russian Orphan": ". . . love binds me to you, just as the ivy climbs up centennial oaks, to be separated from the tree only when it is torn away. . ." The posy of forget-me-nots in Rousseau's hand strengthens his pledge of faith. Yet the declaration is made less to the second wife than to the first. In the clouds hover the heads of the couple's late spouses, Le Tensorer and Clémence Rousseau. The stiff and solemn newly-married couple unite in the oath which subtitles the painting in 1907: "Divided one from another,/ From those whom they loved,/ They joined together,/ Faithful to their memory."

This is the Rousseau who ascribes magic power to painting. Like primitive or non-European votaries of the cult of ancestors, he conjures the spirits of the dead to appease them. He has good reason to do so for he is superstitious. With the Rosicrucians and the symbolist poet Catulle Mendès he took part in séances, and in 1898 even organised such sessions in his studio at 3, Rue Vercingétorix. He felt Clémence's

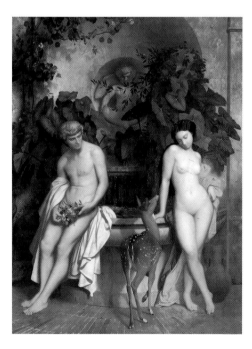

Léon Gérôme
Innocence, 1852
L'innocence
Oil on canvas
Tarbes, Musée Massey

Happy Quartet, 1902
Heureux quatuor
Oil on canvas, 94 x 57 cm
New York, Mrs. John Hay Whitney
Collection

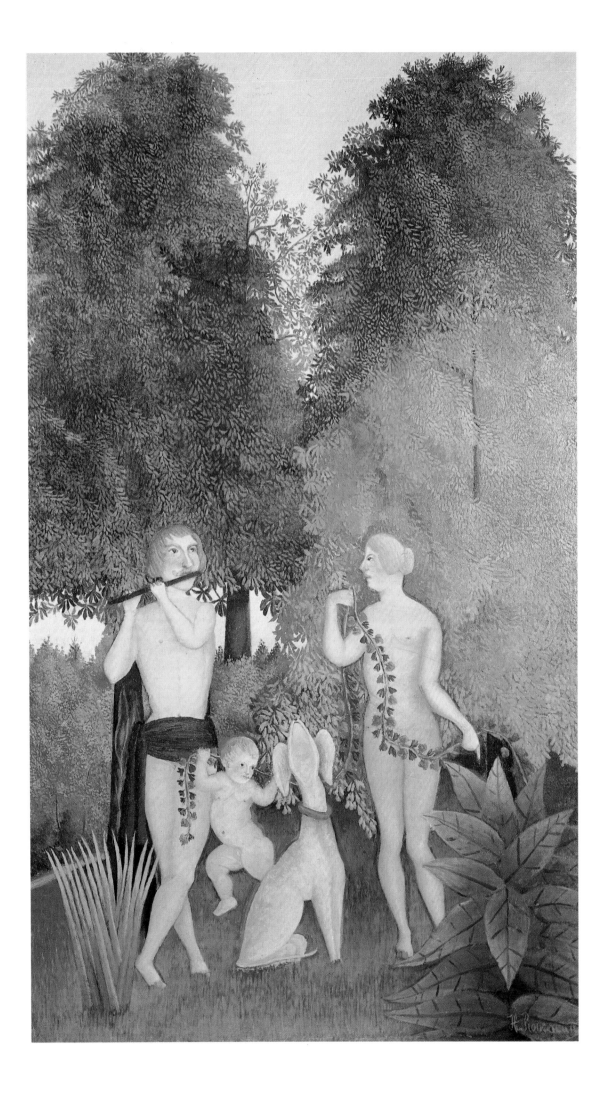

presence close to him to the end of his life, reporting that she often guided the brush in his hand. No doubt these inner forces prevented Rousseau from giving full rein to his imagination in this picture; instead he had recourse to the votive form, easily understood at a trivial level.

There is another possible explanation of this touchingly naive picture. In a late interview with Arsène Alexandre, Rousseau insisted that everybody should be able to comprehend his allegories. In order to clarify his meaning, he often provided subtitles. Rather than trust the picture, he wanted to say what the meaning of the narrative was – an absurd undertaking since allegory depends on multi-layered meaning. The moralist found a highly individual way of resolving the dilemma of wanting to convey messages which were at once cryptic and concrete. Conscious in this matter of his status as a lay artist, he had recourse to techniques and practices of popular art and folklore. Whereas *The Present and the Past* draws on the custom of decorating photographic portraits with floral motifs, so the composition *Happy Quartet* (see p. 31) bears a resemblance to stage backcloths or painted curtains. It may have been modelled on the picture *Innocence* (see p. 30) by the Salon painter Jean Léon Gérôme, one of Rousseau's acknowledged advisers in his early days. It was exhibited in 1900 in the exhibition "One Hundred Years of French Art" which ran concurrently with the World Exhibition – an important opportunity for the Douanier's work to be compared with officially recognised art. The result is highly informative. With regard to the model he takes great liberties, quite apart from the fact that he has difficulty with the nude figure. Alongside the traditional figures of bourgeois culture he places his concrete allegory, the landscaped park as earthly paradise, the ideal figures of the little bourgeois family complete with child and dog, joyfully entwined in the oath of love and faithfulness. Each motif is complete in itself. The artist's only purpose is to suggest to himself and others a happy world, in harmony with the piper's tune. This childish need for an unsullied reality knows no bounds. It is in this spirit that many of the genre pictures, such as the numerous portraits of children, undergo an involuntary transformation into metaphor.

The peak of startling joviality is achieved in the amazingly modern work *The Football Players* of 1908 (see p. 33). The sportsmen hover like cut-out figures in their striped suits before an avenue which might well be in the Parc Saint-Cloud. The composition is radical: there is no transition between bird's-eye perspective and frontal view; the avenue is defined as playing-field by the white fence; the figures are mounted in collage style, like puppets. The picture was painted just at the right moment to commemorate the first international match between France and England, which took place in Paris in 1908; rugby football was still a young game. Yet this profession of faith in popular culture has its share of individual mythology; centre-stage in the choreographic contest Rousseau paints himself, victorious, dreaming as ever of success on all fronts.

The Football Players, 1908
Les joueurs de football
Oil on canvas, 100.5 x 80.3 cm
New York, The Solomon
R. Guggenheim Museum

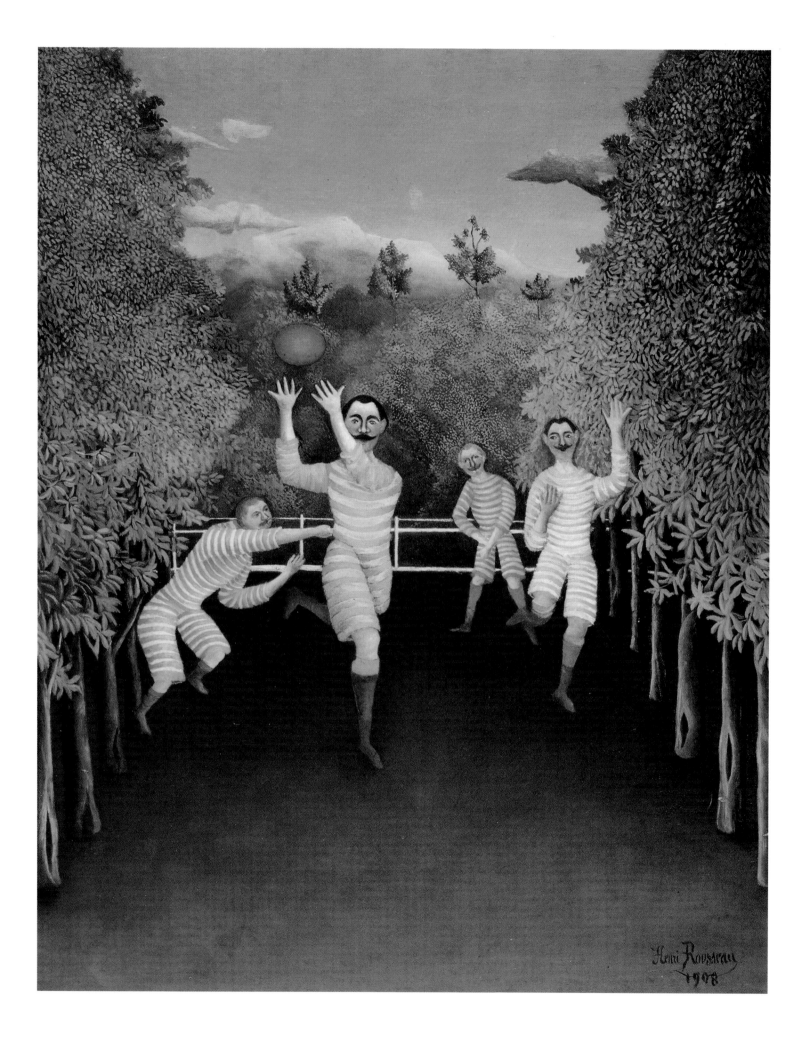

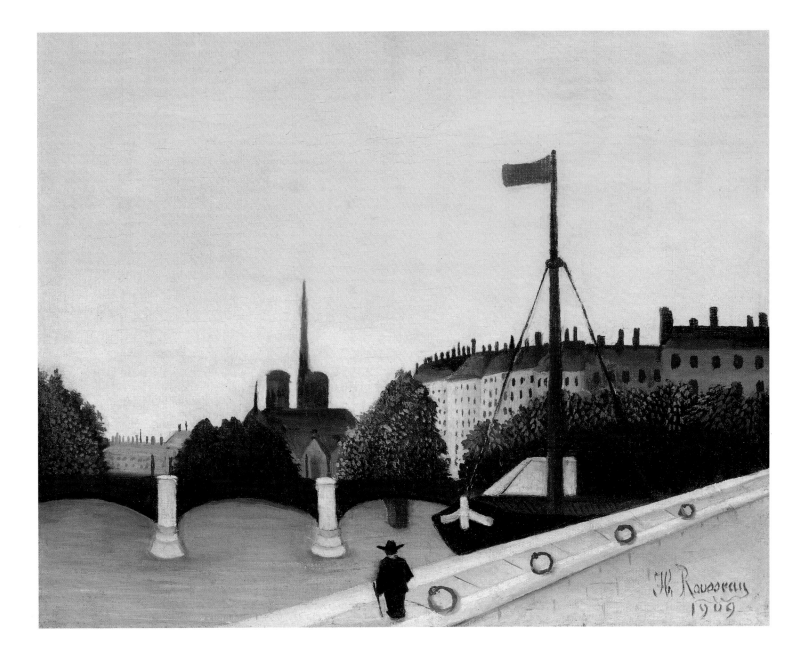

Against the Tide

About seventy rural and urban idylls have survived, making up the largest group in Rousseau's output; further works of this sort have been lost. There would therefore be some reason to describe the Douanier as a landscape painter. However, the accounts book in which he listed his sales to Ambroise Vollard in 1910 seems to gainsay such a classification, in that he accorded his allegorical "creations" ten times the value ascribed to the genre "landscape"; nevertheless he attached such importance to the key motifs developed in the landscapes that he incorporated them into the symbolic portrait-landscapes. In fact this intimate series of paintings is central both to his biography and to the development of his themes and style.

Rousseau's delight in painting originated in the shadows of the gates and toll stations of Paris. Privileged by his superiors, who allowed the stubborn and dour solitary an easy life, he drew and painted his simple environment. The fortifications of the city limits, bridges, such as the Pont de Sèvres, the numerous quays – the Quai d'Auteuil, the Quai du Louvre, the Quai d'Austerlitz – these were places the Douanier frequented, and he knew the metropolis better than most.

Yet unlike the Impressionists, he did not choose to paint the glittering boulevards or the bustling squares or dignified facades of the city. His Paris was a place of quiet, suburban corners, not flamboyant. As in the friezes of the Directoire painter Etienne Bouhot, or the wall-hangings of the "Passage des Panoramas" in his own time, Rousseau's views were of the tranquil flow of the river, of little factories, an occasional funnel and low rows of trees. A shutter is drawn on workaday life, the city and its environs are transformed into a place of rest and recuperation. Only a few motifs – the logs piled on the river bank, heaps of sand – point occasionally to work accomplished. Dark window frames open, as with Giorgio de Chirico, on nothingness. The Seine flows leaden, without ripples, between the accurately drawn lines of its banks. Boats stay "frozen" on the spot. Even the smoke rising, seldom enough, from a factory chimney is motionless in the sky. No breeze stirs, no light shimmers. The only inhabitant of these static planar perspectives is the fisherman or the idler. The contemplative view brings distant objects closer. Every leaf can be counted, every cloud makes an indelible mark. The symmetry of rows of trees and piers of bridges extends time to infinity in the eye of the beholder. Space loses the relativ-

View of the Ile Saint-Louis seen from the Quai Henri IV, 1909
Vue de l'Ile Saint-Louis prise du Quai Henri IV
Study
Oil on millboard, 21.9 x 28.2 cm
Private collection

View of the Ile Saint-Louis seen from the Quai Henri IV, 1909
Vue de l'Ile Saint-Louis prise du Quai Henri IV
Oil on canvas, 33 x 41 cm
Washington (D.C.), The Phillips Collection

View of the Pont d'Austerlitz, 1908–09
Vue du Pont d'Austerlitz
Study
Oil on millboard, 27 x 22 cm
Private collection

ity imposed by rational philosophies. Relations of distance and size defy computation. Each object is given frontal representation, not subordinated to any central focus, and demands detailed attention. The gaze lingers on each element, obliged to follow the order prescribed by the painter's geometrical axes and additive principle.

Whereas Impressionist painting offers the illusion of landscape caught at fleeting moments, Rousseau compels the viewer to reconstruct his landscapes visually, step by step. As in Seurat's pictures, the situation is presented with a totality that extends to the very edges of the canvas: objects, seen in isolation, set in empty space and balanced one against the other, are given value in terms of pure form. The observer has to abandon the solid ground on which he stands and identify himself with the montage figures, thereby entering a strange, immobile reality.

It was with regard to these still-life pictures that the writer Baroness

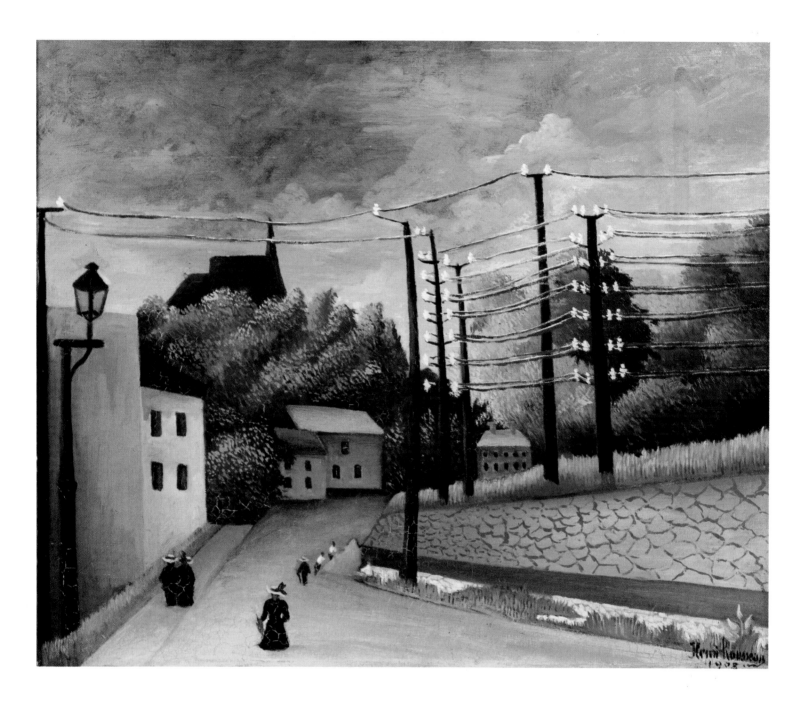

von Oettingen, sister of Serge Jastrebzoff alias Férat, who became known by her pseudonym Roch Grey and was one of the most enthusiastic collectors of the Douanier's works from 1907 on, coined the phrase "Sunday painter". She used it to describe a sociological phenomenon, the autodidact who used his leisure hours to overcome the self-alienation of his working life, in uncompromising pursuit of self-fulfilment. "Every person who works for a living has one consolation, one source of hope, one support that helps him to endure his daily toil: this protecting wall, behind which he may cower all week long, is Sunday. Fifty times a year the labouring man can find leisure to build up his own identity from its foundations, to sense that there are other worlds of thought, other activities, a different life from the one he leads. The only ground on which he can succeed is that of rebellion against the poverty which oppresses him, against the nonsense of all forms of government that cast him down. Product of remarkable coincidences of

View of Malakoff, 1908
Vue de Malakoff
Oil on canvas, 46 x 55 cm
Switzerland, private collection

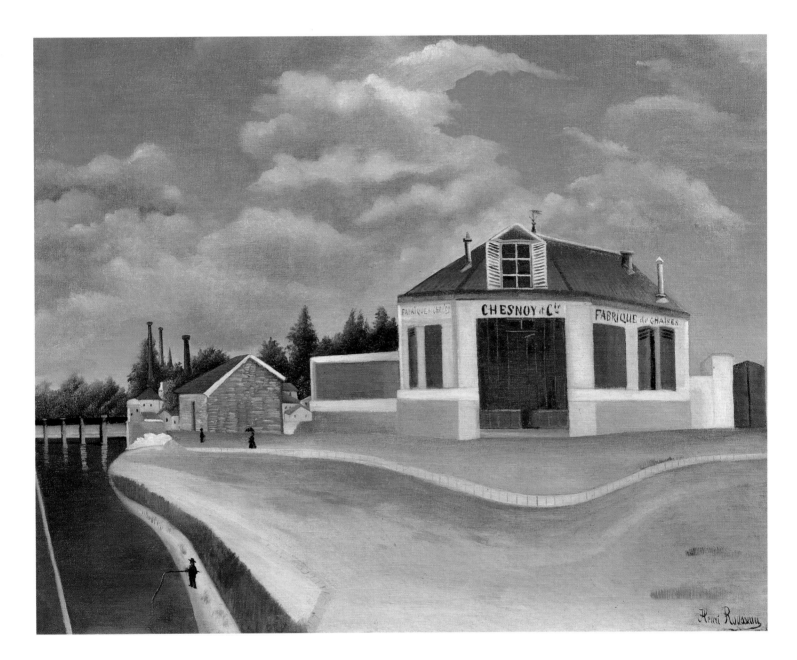

Chair factory, about 1897
La fabrique de chaises
Oil on canvas, 73 x 92 cm
Paris, Musée de l'Orangerie,
Jean Walter-Paul Guillaume Collection

Anglers, 1908
Pêcheurs à la ligne
Oil on canvas, 46 x 55 cm
Paris, Musée de l'Orangerie,
Jean Walter-Paul Guillaume Collection

The Dam, 1904
Le barrage
Oil on canvas, 36 x 48 cm
Paris, private collection

Nature, who in this case has put paradisiac superabundance at the service of world harmony, Henri Rousseau lived without resentment towards his poverty and waited like all the others for his Sunday. Hours of rest during his weekday drudgery enabled him to see birds flying, flowers blooming, wagons rolling past and cattle returning to homesteads on the outskirts of the city; in the dusk everything takes on a gentle tone. Colours are rich and saturated, and reflect no light; for at this hour the sun has gone, and weeks may pass before the moon reaches the fullness that bathes everything in silver. At this hour, the human face is of one colour only, free of the shadows that sharpen features and underline a passing mood . . . All this Rousseau saw, and loved, and he painted it on the glorious Sunday which, the whole world over, makes intensity of joy become the very atmosphere of life." (Roch Grey)

In actual fact, the phrase "Sunday painter" can only be applied to Rousseau with reservations. Although he started to paint in his spare time, in 1893 he decided to retire from the toll service and become a professional painter. His time was no longer at the disposal of others, and he was therefore no longer under the same compulsion to make good the loss; his creativity became autonomous, he entered into competition with others. He no longer lived a double life. Nevertheless he continued to paint landscapes as he had painted them in the beginning, or more so. Released from the toll service, he returned to his old locations, painting them now in more tranquillity than ever. He observed the bustle of Paris from the angle of a rambler who ignores disturbance and lingers in his dream. The streets became empty. Forgotten beauties appeared. The anonymous citizen allowed himself the luxury of an uncorrupted world. The Douanier became the chronicler of an earthly paradise that had no space for everyday problems but gave the promise of "eternal Sunday".

From 1893 he painted increasing numbers of city avenues, parks on the outskirts and village-like places beyond the city walls. The parks of Vincennes and Saint-Cloud, the Bois de Boulogne and the Parc Montsouris were among his favourite destinations, as were Charenton, Alfort, Gentilly, Bagneux, Meudon and Asnières, which could all be reached by rail. Pontoise and Saint-Germain-en-Laye were the most distant places he frequented. Like the Impressionists, he drew motifs from the countryside. Here the scene of World Exhibitions and their emblem, the Eiffel Tower, vanished over the horizon. The city-dweller encountered nature, in which he felt at home, because every last patch was cultivated by human hand. His path took him past fields of crops and saw-mills. Windmills and chair factories appeared on the banks of the Seine (see p. 38). Cattle grazed beneath the poplars on the Marne (see p. 48). Holidaymakers' sailing boats with coloured pennants drifted silently in the twilight bays of the Oise (see p. 43). Dams regulated the flow of the river (see p. 40) and a high railway bridge crossed the valley of the Bièvre (see p. 47). Always the pleasant scene was enlivened by little passers-by and fishermen, who often included Rousseau with hat and stick among their number.

Flight from the city was one of his prevailing needs: he carried with

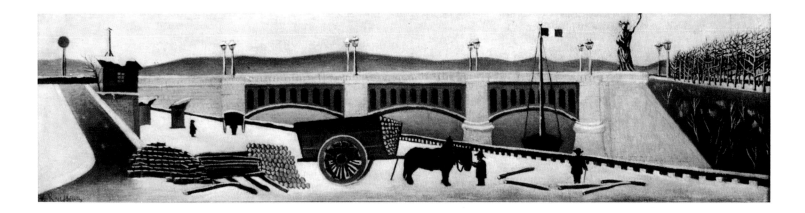

View of the Pont de Grenelle, 1892
Vue du Pont de Grenelle
Oil on canvas, 20 x 75 cm
Paris, private collection

him memories of his childhood in the small mediaeval towns of Laval and Angers, which also, significantly, lie on rivers, the Mayenne and the Loire. Impressions of nature, serene idylls, sleepy towns and villages in which time stood still, remained with him. In search of this early haven of security, he kept the present at bay, painted pastoral scenes and brought the provinces to his representation of the city. He rambled through dreams of the good old times, not very different from those witnessed by the Limburg brothers and Camille Corot. It is hardly surprising that on his travels through simulated inner worlds he often let postcards and picturesque popular photographs of the countryside guide his imagination. Reality at second hand can help to pin down the moment that outside, in the presence of "the thing itself", is transitory.

Rousseau's private mythology joined with his interest in allegory: around 1892 he painted the elongated *View of the Pont de Grenelle* (see p. 41), which was probably submitted unsuccessfully a year later to the competition for the decoration of the town hall at Bagnolet. The picture was built up on hard angles and axes, and it was intended to make a point. The season was winter, the harsh winter of 1891/92, but even more important is the historical significance of the location. In 1889 the French erected a copy, reduced in size, of the American Statue of Liberty on the Pont de Grenelle, at the pointed end of the Ile des Cygnes. The copy was given to the City of Paris by the United States in return for the famous sculpture by Frédéric-Auguste Bartholdis which the citizens of France had presented to the City of New York in 1886 on the occasion of their Independence celebrations. Rousseau created a bizarre inverse image of this light-giving symbol of liberty and linked it with the ship's tricolor, the red part of which was taken up again in the sign-like disc of the sun. Since the bridge appears two-dimensional and foreshortened, and is moreover illogically closed off by an adjoining avenue, the statue and flag enter into a mysterious relationship with the foreground. This is a clue to the point Rousseau is making: both to the carriers loading logs and to the painter in the guise of passer-by, the statue seems to be waving with the honours of the nation and the Third Republic. This picture, therefore, like the allegorical *Myself. Portrait-Landscape* , may be interpreted as a republican's profession of faith. In it Rousseau re-creates the precise structure of the bridge and the lamps, plants the trees one by one, lays one log carefully upon another, affirm-

ing his place as a member of the working population. In accordance with the popular motto of the 1889 World Exhibition, he too celebrates the work of man in the service of France and the concept of liberty.

Always the conscious artisan, the Douanier feels obliged to treat each millimetre of canvas with equal precision. The conservative and democratic cast of mind, which desires to bring order and stasis to the world of appearances, is much in evidence. Since all of his works are fuelled by this wish, the little urban landscape takes on central importance. The desire for order and geometry assigns each object to its place, generates balance, brings peace to reality. The everlasting Sunday and social peace are what Rousseau wanted to convey, particularly in his landscape idylls.

There are eighteen examples of preparatory oil sketches, a phenomenon in lay painting since artists classed as "naive" or "primitive" in general work only with conceptual, emblematic signs. As in the child's imagination the pattern exists within the primitive artist's head and is not modified by perception.

Rousseau has various possibilities at his disposal and this makes it questionable whether he should be put into the category of the naive, where work is by instinct and without awareness. Studies such as the *View of the Pont Austerlitz* and the sketch for *View of the Ile Saint-Louis seen from the Quai Henri IV* (see p. 35, p. 36) were made on the spot, following the Impressionists' custom. With rapid, expressive lines they catch the fleeting moment that brings tremors to telegraph posts, lanterns, trees, buildings and coaches, and resolves familiar objects into transient intangibles. Visible outer reality and the vision that can grasp a fleeting moment are the prerequisites. In the studio the work of transposition, of realisation, is undertaken. The painter transforms the chance selection, constructs with care a whole in which the optical experience is preserved as if in ice. The single motif is given clear contours, planes are created and an architectural pattern emerges which consists of equally weighted elements of form (see p. 34). The situation first perceived becomes, as it often does in Seurat's work, a definitive structure of axes and fields of colour. The countryside observed becomes an artefact.

In this connection it is noteworthy that on the occasion of the Cézanne retrospective of 1907, Rousseau reportedly said: "All of these pictures I could finish, as you know". But it remains an open question whether there was a conscious system either behind his words or behind the processes he applied between study and completed picture. It seems more likely that there were emotional causes for his wish to bring to completion what seemed to him fragmentary. Firstly, there was his admiration for the academic painters Clément, Gérôme, Cabanel, Bouguereau and others. For them also the sketch was only a preliminary to the completed work. In this sense he could be counted a traditionalist, unable to comprehend the affront which Monet directed at the practice of his predecessors. Secondly, his very need for rigour and precision reclaimed for him the recognisable object, which had lost importance at the hands of the Impressionists. He craved a reality at once factual, unassailable and absolute. Things are objectified in the foreground.

"What drink was there for me in this young Oise,
Far from the birds, the herds, the village maidens,
Flanked by tender hazel-nut trees?"
Arthur Rimbaud

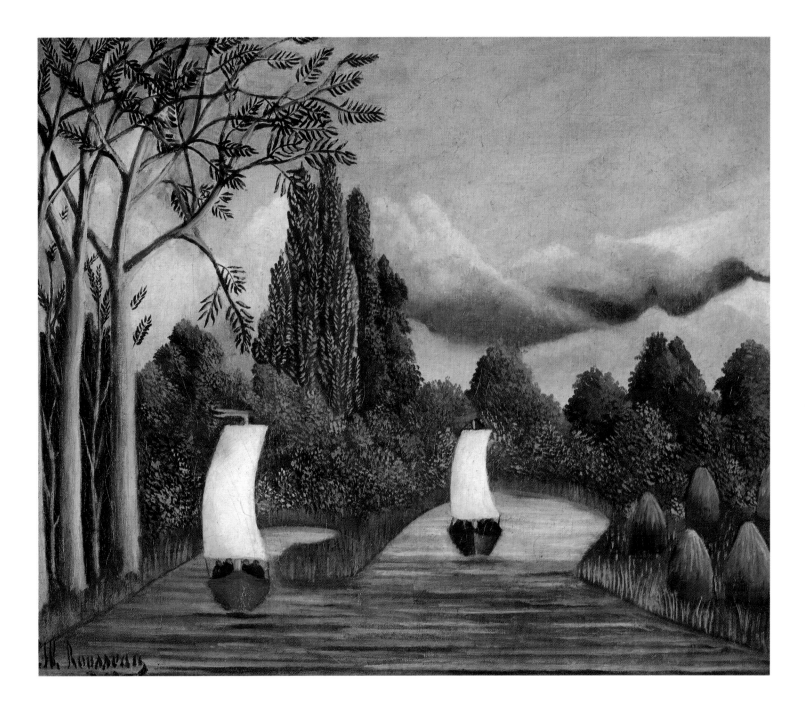

Identities do not change. Motion ceases, time stands still. The illusion takes on the quality of an icon, becomes a concrete surface. In fact this demonstration of firm, refined structures links the Douanier with Cézanne: Rousseau's failure to recognise their common interests can be interpreted as grotesque misunderstanding, or alternatively as evidence of his self-stylisation. Painters such as Pissarro, Gauguin and the Picasso of the 1908 landscapes valued in both artists the synthesis of form. Wassily Kandinsky, who must have seen the "naive" painter's work in Paris as early as 1906, went so far as to designate Rousseau's "great realism" as one of the poles of modern art, with "great abstraction" as the other. In the 1912 almanac of the "Blaue Reiter" he wrote in his essay "On the question of form": "The . . . first germ of great realism is a striving to banish the outer trappings of art from the picture and to give body to the contents of a work through simple reproduction of the plain, unembellished object. The outer shell of the object, perceived in this manner

The Banks of the Oise, about 1908
Bords de l'Oise
Oil on canvas, 46.2 x 56 cm
Northampton (Mass.), Smith College
Museum of Art

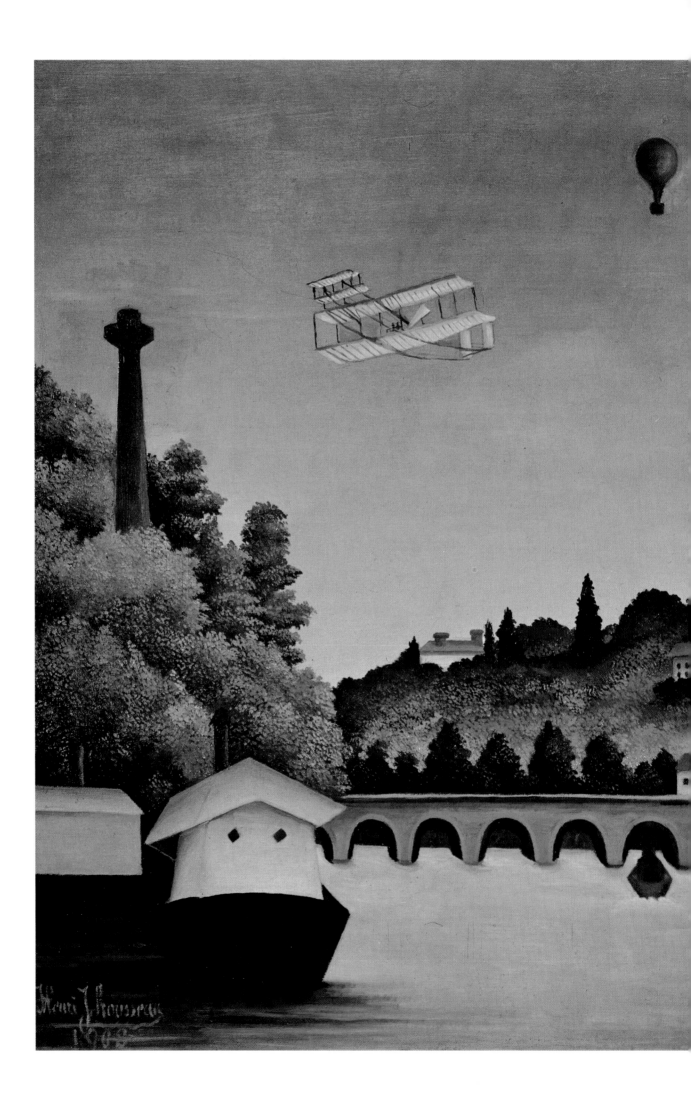

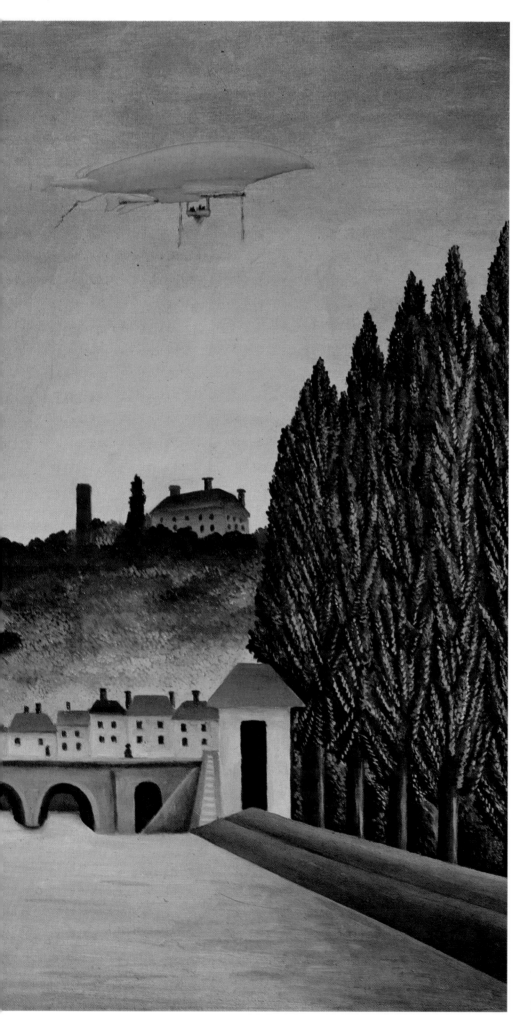

View of the Pont de Sèvres, 1908
Vue du Pont de Sèvres
Oil on canvas, 81 x 100 cm
Moscow, Pushkin Museum

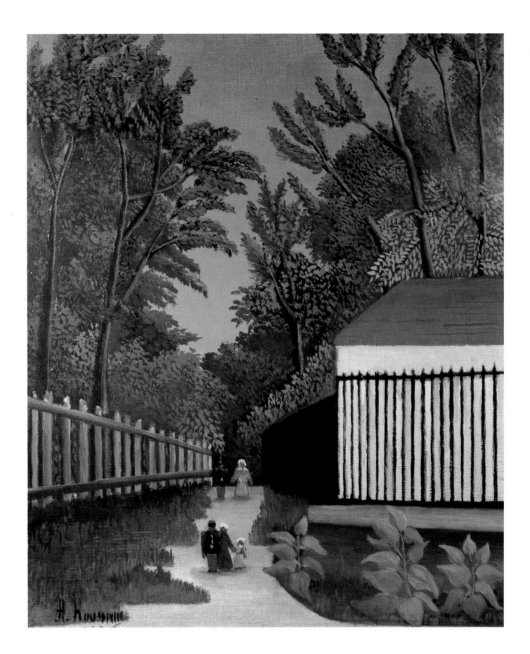

Walk in the Parc Monsouris, about 1910
Promenade au Parc Monsouris
Oil on canvas, 46.5 x 38.5 cm
Moscow, Pushkin Museum

and defined in the picture, and the simultaneous elimination of the usual insistent beauty, can be most reliably relied on to reveal the thing's inner sound." Both the "Pittura metafisica" (of Giorgio de Chirico and Carlo Carrà) and the functionalists chose to follow this path, although the inner sound in their case was not the same as Rousseau's recurring tone: his yearning for security, solidity and civil peace.

There are occasions when the earthly paradise conceived by the "father of grand realism" undergoes complete reversal. In the *View of Malakoff*, for instance (see p. 37), the colossal telegraph posts intensify the stormy atmosphere that lies heavy over the houses and exposes the little figures to the elements without shelter or protection. The hermetically sealed *View of the Pont de Sèvres* (see pp. 44/45) of 1908 takes on a threatening air of mystery. This is no place to be. The boat is caught by the arches of the bridge; the tips of the poplars are enmeshed like metal trellis-work; windows and doors open into black emptiness; ghostly villas rise up out of the dark glow of the overhanging river banks; and double decker, hot-air balloon and zeppelin – signs of the

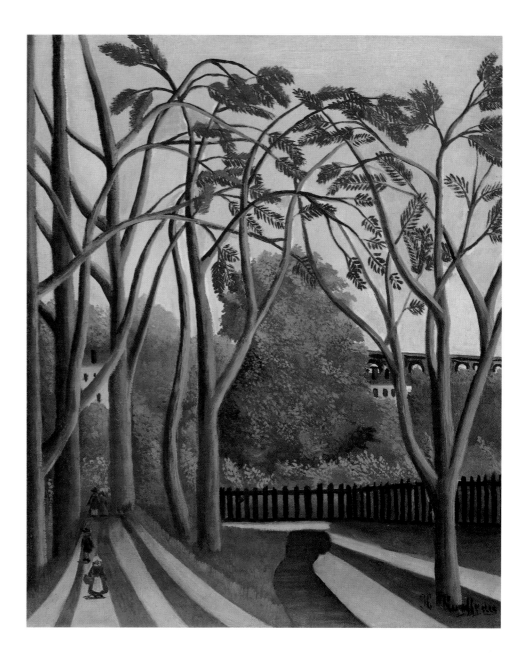

Spring in the Bièvre Valley, 1909
Le printemps dans la vallée de la Bièvre
Oil on canvas, 54.6 x 45.7 cm
New York, The Metropolitan Museum
of Art, Gift of Marshall Field, 1939

technological acceleration of the time – weigh silently from above on the deceptive idyll. The logic of the plane and the oppressive solitude gathering round the painter after the death of his second wife in 1903 contribute to the puzzling, stage-like setting, where danger lurks in the wings.

The Pasture, 1910
L'herbage
Oil on canvas, 46 x 55 cm
Tokyo, Bridgestone Museum of Art,
Ishibashi Foundation

Landscape with Cattle, 1895-1900
Paysage avec vaches
Oil on canvas, 50 x 65 cm
Philadelphia, Philadelphia Museum of Art,
Louise and Walter Arensberg Collection

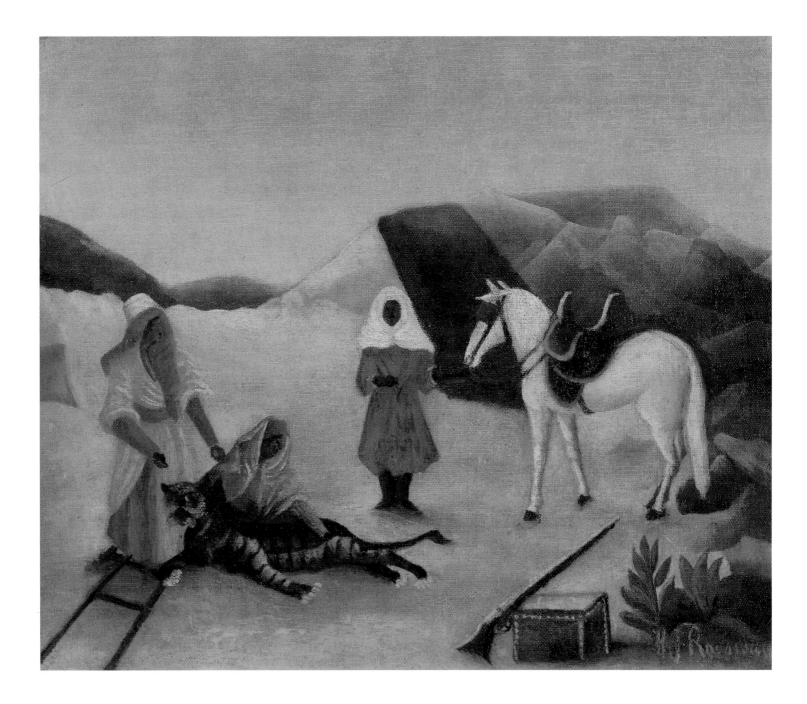

War and Peace

"Spreading terror it rushes past, leaving behind it despair, tears and destruction" is the melodramatic subtitle accompanying the picture *War* (see pp. 52/53), an ambitious work with which Rousseau sought to enter into competition with officially recognised art one year after he had resigned from his position in the toll service in order to paint.

A disturbingly grotesque vision is unfolded in this astonishing composition, which is almost two metres wide and more than a metre in height. Like the distended corpses of drowned men, pale bodies are compressed and confined by two storm-tossed and yet strangely rigid trees – a wave of mysteriously interlocked fragments of truncated rumps, distorted limbs and wig-like scalps. Only a few faces, foremost that of the artist himself, rise up out of the melée. Awkward, wooden, deformed, the figures are splayed between heaps of stones. The hacked-off stump of an arm reaches up, fists are clenched, two booted trouser-legs, feet uppermost, are swallowed by the earth. Menacing black and incisive white erupt with the bloodthirsty crows accompanying the Fury of war: a child, perhaps a young girl, in a white-fringed dress, with sword in hand and flaming brand, storms across the dead land on a spectral steed. Sparks fly from the monstrous horse's hoof; its mane stands on end, rising in panic from the serpentine neck; the dark silhouette of horror is caught in the bare branches, before a sky where orange and pink clouds herald hellish flames of sickly poison. This puppet theatre of the world is without breath, without space, without any prospect of reconciliation.

The bold composition which makes much of strident red, white and black, with back views and a complex maze of forms, betrays the possible influence of pictures such as Théodore Géricault's *Medusa's Raft* of 1819, or Eugène Delacroix's *Liberty leading the People* of 1830. Rousseau, however, drastic as any mediaeval artist, makes the most of the cruel potential of his theme. His difficulties in the representation of the human figure take on a meaning of their own. He exaggerates the distortions which he in any case cannot avoid, and the resulting mutilations are like those of an iconoclast. His *War* is a hallucination of violence and death at the world's end. Landscape and sky take on unnatural colours; black is regarded as matter and the grey tree becomes apocalyptic lightning. The viewpoint is displaced from one angle to another and the human figure is dislocated into segments, anticipating

"Lord, when the fields are cold
Let the cherished ravens descend
Exquisite from the open skies.
In thousands on the fields of France
Where the dead of yesterday lie,
Challenge, as you can, the winter,
Oh black bird of our mourning!"
Arthur Rimbaud

Tiger Hunt, about 1904
La chasse au tigre
Oil on canvas, 38 x 46 cm
Columbus (OH.), Columbus Museum
of Art, Gift of Ferdinand Howald

REPRODUCTION PP. 52/53:
War, 1894
La guerre
Oil on canvas, 114 x 195 cm
Paris, Musée d'Orsay,
Galerie du Jeu de Paume

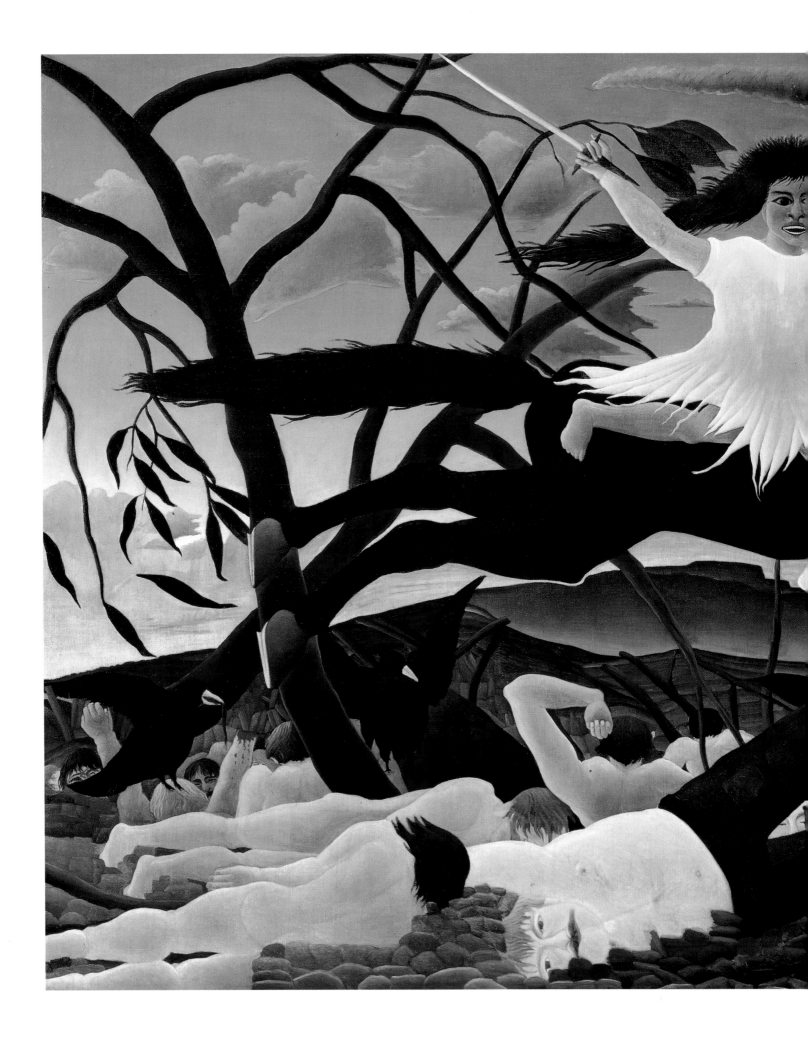

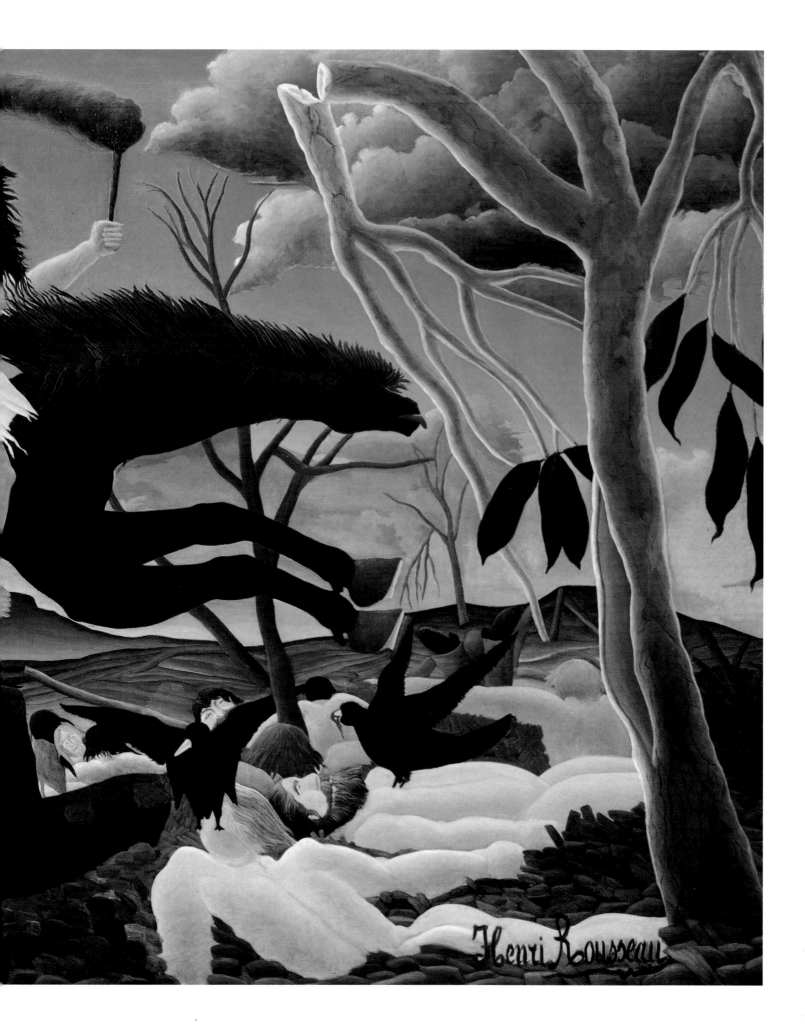

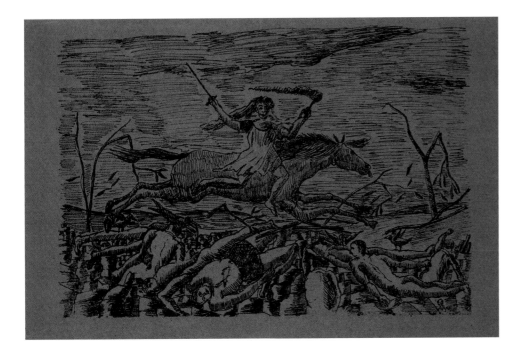

War, about 1895
La guerre
Lithograph, 22.2 x 33.1 cm
Washington (D.C.), National Gallery of
Art, Rosenwald Collection
published in: L'Ymagier, January 1895

Cubism. The dream of reason generates monsters, a sudden shock of vi-
olence never seen before.

The drama of the picture, which has also been called "Discord's
Ride", grew out of a historical situation, reflecting the troubled atmos-
phere of the time. The republican will not have been able to forget the
terrible civil strife that broke out in 1870/71 between the Paris Com-
mune and the royalist government in France. The stone and wooden
structures in the picture call to mind the federalists' bitter battles at the
barricades. Their uprising was brutally put down in the bloody week of
May 21st – 28th 1871 but their ideas of social revolution did not die.
Sustained by the petite bourgeoisie and the freemasons – to whom
Rousseau belonged – the anarchical movement intensified during the
early 1890s, the time at which this picture was painted.

Interestingly enough, it was from the circle of intellectuals intent on
transferring political anarchy to the cultural sphere that the man who
"discovered" Rousseau came: the poet Alfred Jarry. This young man of
legendary brilliance had close links with the Symbolist circles around
the writer Rémy de Gourmont, Rachilde and Vallette of the "Mercure
de France", and the Natanson brothers of the "Revue Blanche". Ag-
gressive, cynical, born – like Rousseau – in Laval, the inventor of
"Ubu" and "Dr Fistroll" met the Douanier in 1893 when he himself
was only twenty years old, and befriended him. The controversial artist
of the Salon des Indépendants was bound to appeal to him. In him
Jarry found the unwitting bugbear of the bourgeoisie, the freak who
turned their scale of values upside down without knowing it. He recog-
nised the possibility of setting up the indomitable painter as figurehead
of the counter-civilisation that the Symbolists championed against all ra-
tionalist philosophy.

Jarry wrote two articles on *War* , for the summer 1894 issue of the
journal "L'Art littéraire" and for "Essais d'art libre", and he explained
that for him the important thing about Rousseau was the primeval

power of his imagination. For the openness of the work of art he chose poetic metaphors, the illogicality of the prose poem, and he renounced in the process all thought of naturalism. He went on to place the painter firmly in the context of what was to become one of the most important aesthetic movements of the time. In the journal "L'Ymagier", which he edited jointly with Rémy de Gourmont, he published in January 1895 Rousseau's only graphic print, a lithograph inked against a red background, a variation on the composition *War* (see p. 54). The simplified and comparatively schematic structure indicates that the print does not represent a preliminary study but a later version. It is patently difficult for the Douanier to reduce the format of his monumental work. The dire immediacy of vision, the boldness of concept are lost. Yet the stiff reproduction has a vital place as a source document. For one thing, it makes it likely that Rousseau was encouraged to compose his allegory of war by a political caricature (see p. 55) which had appeared in the newspaper "L'Egalité" in 1889. For another, it gives the artist a place in the anonymous sphere of "imagerie", the delight in putting on a show, which had been a living force in popular art since the Middle Ages.

From Gustave Courbet to Wassily Kandinsky, all those who sought an escape from the cul-de-sac of officially sanctioned art had revered the popular tradition. Many years earlier than the almanac of the "Blaue Reiter", Alfred Jarry gave expression to this subversive admiration. In "L'Ymagier", as in the journal "Perhindérion" which he edited in 1896, he wrote in uncompromising terms of the power of the direct and archetypal symbol. He cited examples largely from religious works in Gothic style, or motifs drawn from overseas, and set out to compare them with the deliberately primitive works of Gauguin and Emile Bernard, and with his own, and wrote accompanying texts which emphasized the enigmatic and hermetic character of allegory. The Symbolist notion was to reject optical reality, and to establish the moment of creation as part of real and inexplicable mystery, restoring art to its true place, to cult and ritual. In this scheme of things, Rousseau was accorded the position of popular cult artist, as was the printer Georgin with his woodcuts for the workshops at Epinal (see p. 55). In his play "Dr Fistroll" Jarry even had the Douanier appear as manager of a painting factory which creates new works out of the monstrosities of the national warehouse, the Musée de Luxembourg. There is no mistaking the critical commentary on culture. However, although this helped to spread the legend of the lay painter it did not do him justice. His astonishing composition *War* could not be reproduced in picture pamphlet dimensions. The little print had nothing of the force with which the child in Rousseau took vengeance on the stratified grown-up world.

In 1897 the Salon des Indépendants showed a work which outdid by far even Jarry's "pataphysics", the "science of imaginary solutions, of the rules that proved the exceptions". While the poet was concerned with the methodical construction of chance, the idea of this particular picture is a reductio ad absurdum of every attempt at explanation. It is the wide canvas scene of The *Sleeping Gipsy* (see pp. 58/59), with the lapidary subtitle: "Although the predatory animal is wild, it hesitates to

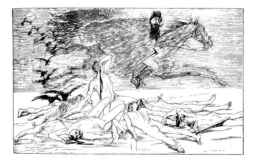

Anonymous
The Tsar
Le tsar
Caricature, published in:
L'Egalité, 6 October 1889

F. Georgin
Battle of the Pyramids
La bataille des Pyramides
Colour lithograph, Epinal picture broadsheets
Paris, Musée des Arts et Traditions Populaires
published in: L'Ymagier, January 1895

Giorgio de Chirico
Gladiators and Lion, 1927
Gladiatori e leone
Oil on canvas, 130.5 x 162.5 cm
Detroit, The Detroit Institute of Arts

leap upon its victim, who has fallen fast asleep from exhaustion". The
picture is so startling that when it was rediscovered at a Paris coal-mer-
chant's in 1923 by Louis Vauxcelles, there were animated debates as to
whether Rousseau had really painted it. A rumour circulated that it was
a forgery painted by Picasso. Yet the modern quality of the composi-
tion is founded not on theory or systems but on intuitive structures.
The two-dimensional shapes of mandoline and jar, and the geometrical
angles of arm and stick, anticipate Cubist techniques. The shining rain-
bow dress of many colours and the pink locks of hair, like the sandhills,
give the recumbent figure the appearance of an autonomous flow of col-
our such as the Orphic circle round Robert Delaunay was to strive for
in a different way. But it is above all the inherent magic which makes
this picture resemble the dream landscape of a Symbolist or "Surnatu-
ralist." There is no "chance meeting of an umbrella and a sewing-ma-
chine upon a dissecting table" of the kind proposed by Comte de Lau-
tréamont as the pre-Surrealist model of the unconscious, and yet the
meeting of lion and gipsy is in its way even more of a puzzle. The alogi-
cal happening materialises in hyperrealistic concrete forms; moreover,
this reality defies a rational approach and retains its ambivalence.

The tension between the menacing and the soothing cannot be re-
solved. What is the source of the wind that lifts the lion's mane in the
still moonlit night? Is the sharp contour of the bank not a protective
screen between two irreconcilables? Is the wild animal part of the
strangely daemonised woman's dream? Is it perhaps an erotic projec-
tion, in which the painter as male lion imagines his beautiful prey? Or
has the spiritualist Rousseau conjured from the depths of sleep the ar-
chetypes of the self, unbridled feelings and the black, unknown anima?

All these questions are ultimately silenced by the picture; its montage betrays, in the words of André Breton, "the effect of magic causality". Only in the world of fantasy can it happen that unchecked by reason the bell of the stringed instrument, the dark face of the gipsy and the full white moon enter into a secret relationship with one another, that the moonlit tip of the lion's tail becomes the painter's outsize brush.

The Surrealists attached immense importance to Rousseau's "peinture-poésie". The loveliest description of the painting was written by Jean Cocteau in 1926: "What peacefulness! The mystery believes in itself and is revealed, naked ... The gipsy sleeps, her eyes are closed ... What words can describe this figure, immobile and flowing, this river of oblivion? I think of Egypt, that could sleep in death with eyes open, as if diving under water ... Whence does such a thing descend? From the moon ... and it is probably not without reason that the painter, who never overlooked a single detail, carefully avoided any tracks in the sand around the sleeping feet. The gipsy did not pass this way. She is here. She is not here. She has no human place. She lives in mirrors ..." This key work of fantasy surpasses even the Symbolist art of the time and can therefore be seen as a forerunner of the metaphysical painting of Giorgio de Chirico. Its contents should not be sought in the complexity of ideas but in the reality of things that have changed places. The impossible becomes possible; the observer reaches a point where language is no more.

The picture, calling to mind the ritual conjuring of spirits, reveals the sources of Rousseau's dream material. The monumental composition rivals the Oriental style of painting represented to excess by his mentors, the neo-Classicists Gérôme and Clément, amongst others. Like them he concentrates his attention on the foreground, constructs with a craftsman's precision a perfect planar balance and exaggerates the beauty of artifice. With his first jungle picture, *Surprise!* of 1891 (see p. 2), the ambitious newcomer had already ventured on the exotic genre that was one of the most widely recognised of the Belle Epoque. Rousseau's urge to compete with the painters of the Orient by his own artistic means was intense, as is shown by *Tiger Hunt* (see p. 50) and by *Unpleasant Surprise* (see p. 75), which was so greatly admired by Renoir. Behind this urge one may well sense the permanent quest for recognition. It would be no surprise if it should turn out that with *The Sleeping Gipsy* , as with War, Rousseau had in mind a political allegory – in this case a tribute to national peace and France's colonial power. Yet the deceptive idyll, the conflict between peace and threat of violence, pervade the whole of the Douanier's private mythology. It was his desire to escape humdrum reality that opened the way to exotic themes and led him mystified towards great mystery.

REPRODUCTION PP. 58/59:
The Sleeping Gipsy, 1897
La Bohémienne endormie
Oil on canvas, 129.5 x 200.7 cm
New York, Collection, The Museum of
Modern Art,
Gift of Mrs. Simon Guggenheim, 1939

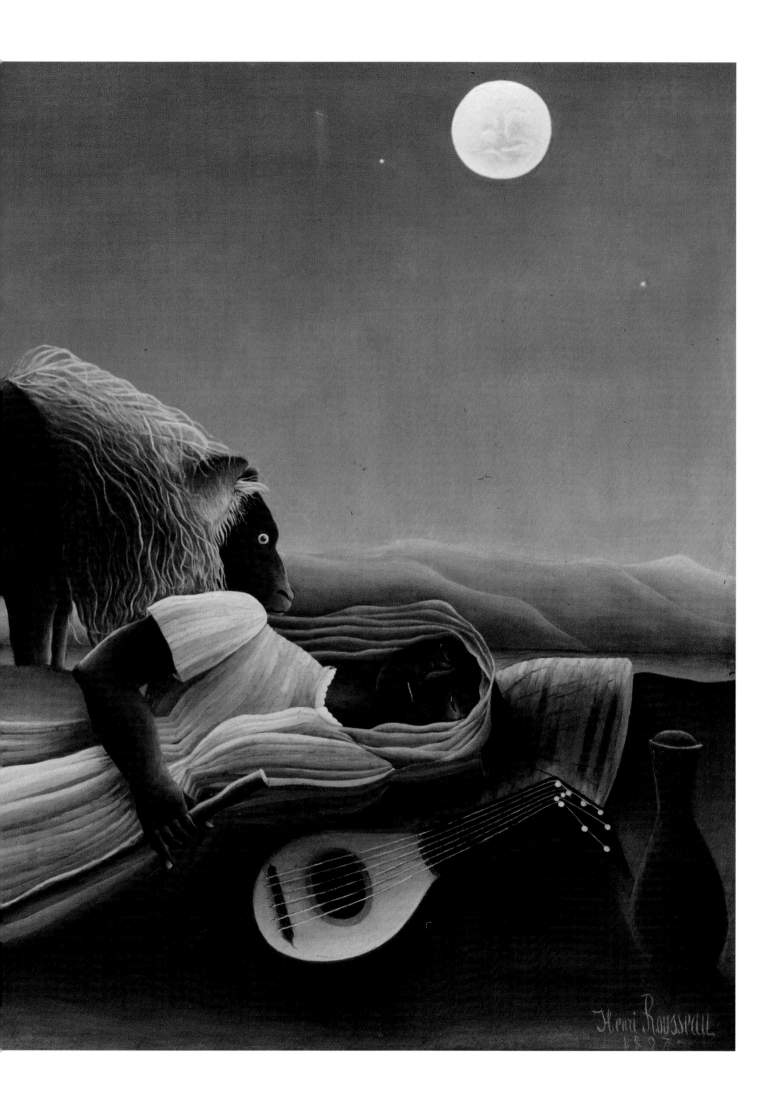

Erring Portraits

In spite of the invention of photography and the pure painting of the post-Impressionist avant-garde, the portrait remained exposed to conventional criticism more than other genres. The person commissioning a portrait wants to see himself in his likeness as in a mirror. The viewer looks for the similarity between the sitter and his picture, or at least for the illusion that the person painted could somehow inhabit the same world. The painter wants to demonstrate his ability to stay close to nature, and wants at the same time to emphasise that art is autonomous and cannot be constrained.

The portraits that Henri Rousseau exhibited from 1889 in the Salon des Indépendants were usually commissioned and they were usually misunderstood – often, indeed, violently rejected. The portrait-landscape *Boy on the Rocks* (see p. 70) was labelled by the press the "Dwarf with the Enormous Head" and established the painter's reputation as a freak. It sometimes happened that people from his own quarter who asked him to paint themselves or their children rejected the result or perhaps destroyed it. Even Alfred Jarry destroyed his likeness that was mistakenly exhibited in 1895 as *Portrait of Madame A.J.*; it showed the poet clad in black, surrounded by his favourite creatures, owl and chameleon. Jarry used the picture for target practice, set fire to the canvas and kept the remaining fragment rolled up in a drawer in order to shock visitors. This, at least, is the story told by André Salmon and by Guillaume Apollinaire who, as late as 1906, saw the remains of "a most impressive head". Apollinaire made the acquaintance of the Douanier in 1906 through Jarry, and like him he was confronted with an unusual way of working when he sat for his spectacular double portrait (see pp. 60, 61). Rousseau is said to have taken the exact measurements of his model's face and body in order to transfer them, reduced in size but proportionally exact, to the canvas. Moreover, he allegedly held his tubes of paint up to the sitter's face in order to find "the precise tone of the flesh". The reports of the two subversive poets delight in the fame of the ridiculous painter, who in their eyes was a simpleton with a touching desire to imitate nature but whose bureaucratic pursuit of detail barred the way to an overall impression. There is something particularly entertaining in the logic of the absurd, which all parties had in common. For Rousseau, a human being was a concrete object that could be reconstructed in the same manner as a piece of furniture, so

The Muse inspiring the Poet, 1908–1909
La muse inspirant le poète
First version
Oil on canvas, 131 x 162.5 cm
Moscow, Pushkin Museum

The Muse inspiring the Poet, 1909
La muse inspirant le poète
Second version
Oil on canvas, 146 x 97 cm
Basle, Kunstmuseum

that the surface of the painting becomes a technical designer's projection screen. For Jarry, the picture that came about in this way was merely created matter and therefore a fit object of attack.

The belief that a likeness could be built up from measurements, like the photo-kit reconstruction of a wanted person, resulted in an unusual style of portraiture. The basic scheme is provided by the pictures of children (see pp. 69, 70, 93). The figure faces the front and is fixed in position by a precise outline, always sketched in first. Since the face comes at the beginning and holds most meaning, relatively little room is left beneath the "Japanesque" head for the body. Details such as hands, accompanying objects, the pattern of a dress, legs, are compressed. Since Rousseau constructed the figure additively and without regard to perspective foreshortening, it turns out in segments like the pieces of a puzzle; the simple fields of colour cause the flesh tints to hover in front of the black and behind the red. This deformation arose from deficient technique, yet it is so clearly defined that in the most astonishing way it anticipates Cubism. The figure becomes a multi-layered structure, resulting not in likenesses of the known but in art shapes, precursors of Chirico's articulated dolls which confront the observer like rigid, iconic masks. The collage-style landscape, too, "cut and pasted" during the second phase, is fictitious in content. The meadow full of flowers spreads out behind the girl, the mountains tower up behind the boy. Perhaps the inventor of the portrait-landscape intended to convey aspects of childhood, safety and adventure. But unlike the key picture of 1903 (see p. 93), these pictures do not present the world of childhood as a primeval paradise. The solemn children look like small adults. Self-contained, immobile, solitary and forlorn, they embody the constraints and alienation bestowed upon them by the painter. The dominant contrast between black and white in the picture of the boy has been taken by some to suggest the likeness of a dead child. Perhaps Rousseau's perceptions were coloured by his own experience and feelings. Four of the children of his first marriage died young. Julia, the only daughter to survive, was taken to live with relatives in Angers when she was eighteen years old. Her role in the Douanier's bohemian life was negligible.

Every model who sat for Rousseau was disturbed by his preoccupation with planes and detail. Whether he was painting a leaf, the arch of a bridge or a human being, he always contradicted intuitively the reality people knew, and arrived at magic formulas stylistically modern in spirit. Fundamental to the magic of the portraits is that the "things" conjured might well have come from a puppet theatre, and yet they catch the essence of the subject's world.

The small *Portrait of the Artist* (see p. 63), which was painted around 1900, reveals something of his image-conscious personality. With black lacquered hair, precisely twirled moustaches and well-cut dinner jacket, he assumes his position as stalwart man of honour and energy. Although he chooses a modest format for the picture, yet the smallest detail of his face and the severe black-and-white of his evening dress express the full quantum of self-assertion. This is the proud representative of the Third Estate, the roguish bohemian and serious artist, who distributes visiting cards with the imprint "fine art painter", who

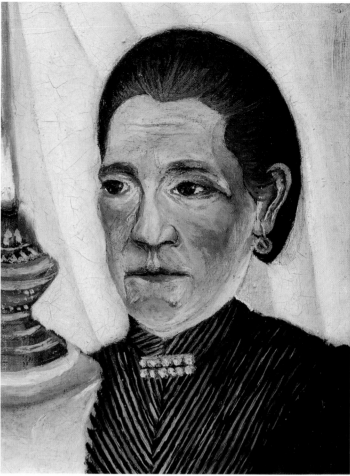

gives private painting and violin lessons to the people of his neighbour-hood and, from 1902, teaches for the Association Philotechnique. Not without reason did the artists of the "Blaue Reiter" attach importance to this self-portrait. At Christmas, 1911, Franz Marc gave Wassily Kandinsky a mirror-image replica in verre églomisé, which gave the "painter with the sacred heart" flower and halo. Not without reason did Max Beckmann refer to Rousseau in his famous *Self-Portrait in Dinner Jacket* of 1927 as the "Homer in the Porter's Lodge" who could both portray and transcend the petit bourgeois world.

The matching *Portrait of the Artist's Second Wife Joséphine* (see p . 63) gives evidence of the poverty and hardship which the painter liked to conceal. Joséphine, whom he had married in 1899, opened a small stationery shop in the Rue Gassendi in 1901, hoping to sell, among other things, her husband's works. In the picture she appears ill and prematurely aged; she died in 1903.

Other pictures capture the as yet unshaken world of the worthy, phlegmatic citizen. The artillerymen (see p. 66), the guests at the country wedding (see p. 67), those going on a Sunday excursion in the cart of the neighbourly greengrocer Claude Juniet, including the dogs and the white mare Rosa (see pp. 64, 65) – all of them are motionless under the painter's gaze. Like a photographer, he arrests all movement and seizes the solemn moment. Rousseau does everything possible in order to achieve ceremony. He positions the wedding guests in front of

Portrait of the Artist, about 1900–1903
Portrait de l'artiste
Oil on canvas, 24 x 19 cm
Paris, Musée du Louvre, Picasso
Foundation

Portrait of the Artist's Second Wife Joséphine, about 1900–1903
Portrait de la seconde femme de Rousseau
Oil on canvas, 22 x 17 cm
Paris, Musée du Louvre, Picasso
Foundation

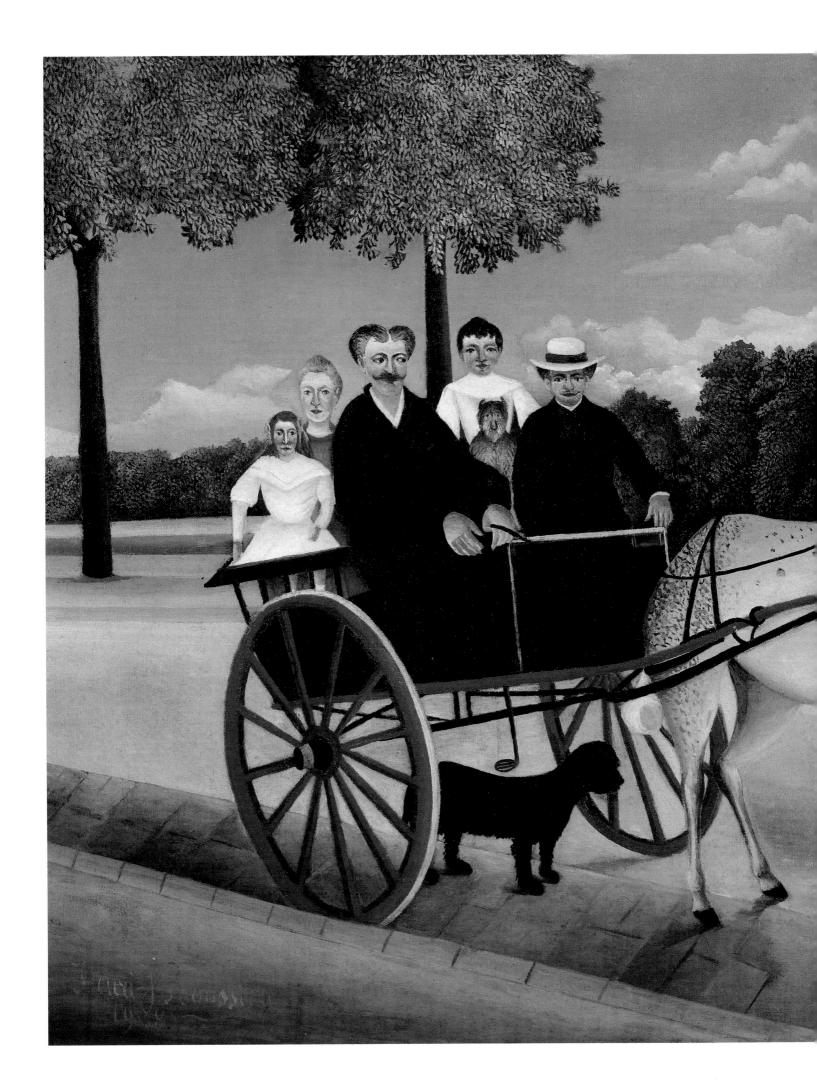

The Cart of Père Juniet, 1908
La carriole du père Juniet
Oil on canvas, 97 x 129 cm
Paris, Musée de l'Orangerie,
Jean Walter-Paul Guillaume Collection

Artillerymen, about 1893–1895
Les artilleurs
Oil on canvas, 79.1 x 98.9 cm
New York, The Solomon R. Guggenheim
Museum,
Gift of Solomon R. Guggenheim, 1938

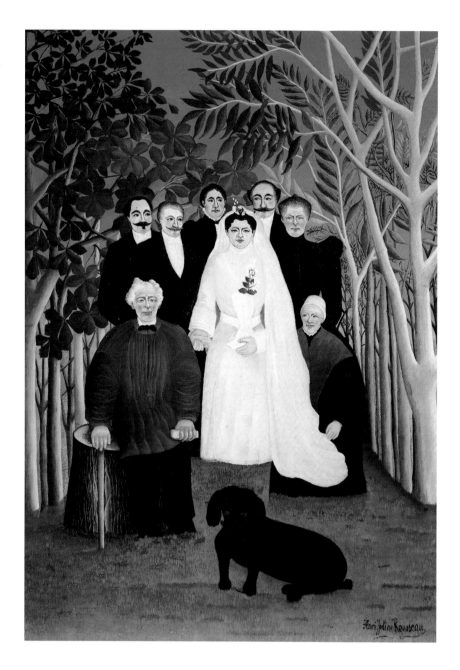

A Country Wedding, 1904–1905
Une noce à la campagne
Oil on canvas, 163 x 114 cm
Paris, Musée de l'Orangerie,
Jean Walter-Paul Guillaume Collection

chestnut trees and acacias which outdo the naturalistic trappings of the photographer's atelier, and achieves a kind of fantastic reality. By means of simple outlines and black-and-white contrast he gives the static group close cohesion. Problems of representation the painter overcomes by imbuing the figures with a magic quality: the man sitting down seems to become one with the tree-stump. and the bride defies gravity and hovers in the centre of the group; the hyperdimensional black dog becomes a kind of totem animal and at the same time provides the balance that the picture requires.

An anecdote concerning the group picture, *The Cart of Père Juniet* (see pp. 64, 65), demonstrates Rousseau's characteristic attitude. The American painter Max Weber, pupil of Henri Matisse, pointed out to the Douanier that the dog underneath the cart was so large as to be out of all proportion. Rousseau's answer, "Because it has to be that way", is not in the least naive. Comparison with the photographs from which he worked show that each motif was thought out, as a formal element of composition. The tree appearing behind the group is emphasised as an axis repeated in the proudly seated figures. An additional person fills the gap behind the owner of the cart. The piece of wood blocking the horse in the photo disappears. The dog with its black silhouette offsets the precariousness of the cart, and even the disproportionately tiny puppy finds its counterpart in the crotchet-shaped pedal. Everything, except the black-white-red contrast in front of green, yellow ochre and blue, has its place in the scheme of balance. In this incidental picture, which, like Pop Art, constructs "reality at second hand", one motif is particularly striking: presumably with the pantograph, Rousseau copies the wheel with its spokes in "correct" perspective. This hyperrealistic item disturbs the tapestry-like quality of the picture. It is at this point that magic takes over. The consistent two-dimensionality of the scene triumphs over conventional perception, transforms the one remaining piece of everyday reality into something strange.

In the exotic portraits with which Rousseau bids farewell to the petit bourgeois world, the form becomes even more radical. The head-and-shoulders portrait of a man dressed in oriental style, accompanied by his tabby cat with tiger stripes, sitting before an urban industrial landscape, was painted about 1905 (see p. 73). It is not certain whether this portrays the popular writer and traveller Pierre Loti, or a certain Edmond Frank, journalist and poet of Montmartre, who in 1952 recognised himself in the picture. Be that as it may, Rousseau knew how to stage the eccentricities of the poet. The dandy with his cigarette would not be out of place beside the "islander" Gauguin or the magician Sàr Péladan. Constructed like a playing-card in black, white, red and yellow ochre, the figure casts a spell over the melancholy sea of houses; in the spirit of Paul Verlaine he raises the song of the leaf from the ash of the city. The matching of colour shapes, the collage-style hand that echoes the chimneys, the ear flattened two-dimensionally and the face with its almost Cubist facets – all these features combine to give the work a rigour which is reminiscent of late Gothic painting, and a modernity not found again before Léger.

The *Portrait of Joseph Brummer* of 1909 (see p. 72) seems conven-

"The figures are tranquil as gods keeping watch over eternity. They are free from suffering, safe from deprivation and sorrow."
Christian Zervos

Portrait of a Child, about 1905
Portrait d'enfant
Oil on canvas, 67 x 52 cm
Paris, Musée de l'Orangerie,
Jean Walter-Paul Guillaume Collection

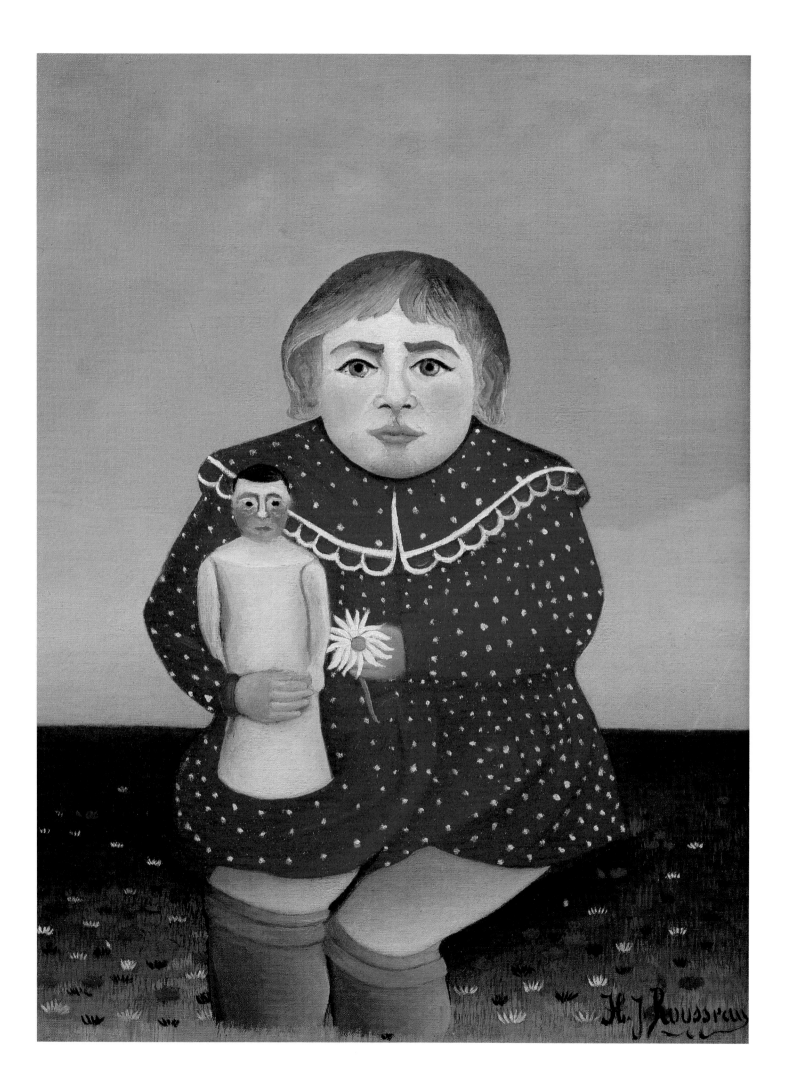

tional by comparison. The picture suggests that Rousseau had been studying *Monsieur Bertin* by Ingres which had been in the Louvre since 1897. Equally compact and monumental, black and white, complete in itself, the figure of the young Hungarian-born sculptor sits enthroned before the observer. The painter and his model were introduced to one another in 1908 by Matisse's pupil Max Weber. Brummer was also studying with Matisse and acting as assistant to Rodin and he was one of the increasing number of artists and intellectuals who gathered round the spectacular Douanier and counted themselves fortunate to be invited to his private soirées.

Behind the casually elegant figure Rousseau painted a cryptic picture within the picture. It is the encoded signature of the proud inventor of the jungle landscapes and at the same time it celebrates the successful connoisseur and dealer who bought and sold not only Japanese woodcuts and African sculpture but also the works of the so-called primitive.

The most colourful of all the aggressive young artists of the modern style was Guillaume Apollinaire, the metaphysical poet and later theorist of Cubism, who was introduced to the painter by Alfred Jarry in 1906. By mid-1908 Rousseau had conceived his plan for a double portrait that was to show the poet and his mistress, the painter Marie Laurencin, in a corner of the Parc de Luxembourg (see p. 61). The couple's dilatory attendance at sittings and their disregard of Rousseau's financial straits meant that the work was only just completed in time for the exhibition at the Salon des Indépendants in March of the following year. The result is not entirely free from caricature. The poet's pose is that of a well-behaved schoolboy with Marie towering at his side. In a second version, undertaken so that Rousseau might put right his earlier error of putting gillyflowers instead of carnations in the picture, he persisted in his interpretation of the great poet's need for a large muse (see p. 60). This bizarre story gives the lie to Apollinaire's myth of the Douanier at heaven's gate and innocent Fra Angelico; the naive cult figure of the artists' banquet portrays the vanity of his subject with mischievous precision, painting the second time from memory. The "semiotic error" confirms the value of the measuring technique Rousseau used for the first version. Press critics found the picture a poor likeness, but this criticism in itself confirms the identity of the subject, just as the shots fired by Alfred Jarry at his own portrait confirm his desire to destroy the Ubu in himself.

Boy on the Rocks, 1895–1897
L'enfant aux rochers
Oil on canvas, 55.4 x 45.7 cm
Washington (D.C.), National Gallery of
Art, Chester Dale Collection

Portrait of Joseph Brummer, 1909
Portrait de Joseph Brummer
Oil on canvas, 116 x 89 cm
Private collection

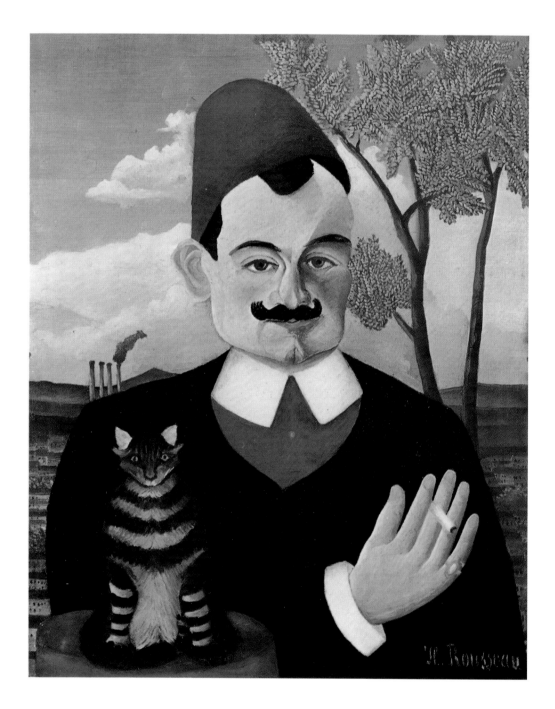

Portrait of Pierre Loti, about 1891
Portrait de Pierre Loti
Oil on canvas, 62 x 50 cm
Zurich, Kunsthaus Zürich

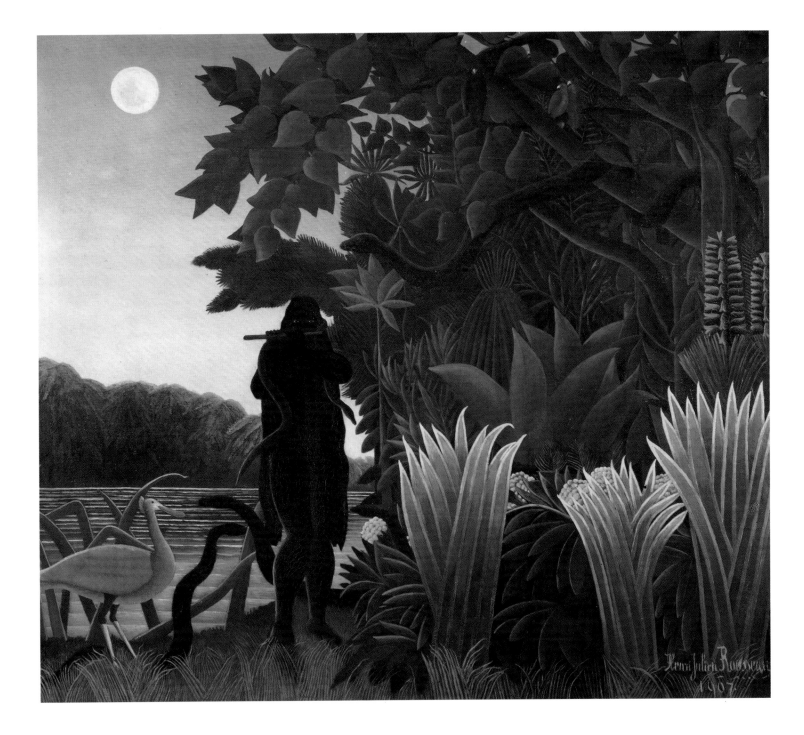

Jungle Cabinet

In the year following the ambivalent success of *Myself. Portrait-Landscape* (see p. 18), namely in 1891, the Salon des Indépendants presented a sensation which put everything else in the shade. This was the painting *Surprise!* (see p. 2) which shows a cut-out picture tiger about to pounce amidst fronds of yellow, green and red vegetation. The result was moral outrage. The laughable newcomer Rousseau seemed to be associating himself with artists such as Delacroix who, since the Romantic era, had furnished colonial France with exotic themes. Is there indeed any sense in this "iconography"? Has the wild animal been caught in the storm, is it stalking some invisible prey, or does it simply illustrate the elemental force of nature in the wild? The press took a positive view of the Symbolism of the time and made favourable comparisons with Japanese tapisserie. Félix Vallotton, who later joined the Nabis, wrote in the "Journal Suisse" the first article commending the artist's innovatory powers: "Monsieur Rousseau becomes more startling every year . . . Moreover, he is a terrible neighbour because he makes everything around him seem like nothing. His tiger taking its prey by surprise should not be missed on any account; the picture is the alpha and omega of painting . . . It is always magnificent to see conviction of whatever sort given such relentless expression."

Indeed there is no denying the radical consistency with which Rousseau pursued his aims. In this picture even more forcibly than in the woodland tryst, *Rendezvous in the Forest* (see p. 11) of 1889, the observer is made aware of the "horror vacui" texture, perhaps attributable to the influence of the Gothic tapestry and weaving which had impressed Rousseau in Angers and in the Musée de Cluny. The composite ornamentation results in a faceted style which perfectly conceals any problems the artist might encounter with figure painting and space. The effect is achieved within the single plane.

The post-Impressionist Avant-garde and Art Nouveau also sought ways of transcending conventional optics, attaching paramount importance to the inherent laws of art. It fell to Rousseau to provide the solution which eluded the more intellectual artists. He took as his starting-point the visible objects of extrinsic reality, and by according to each its truly distinctive character he won from Nature his own technique. The botanical leaf provided the basic structure, with endless possibilities of repetition, variation, seriation and multiplication. The leaf guarantees

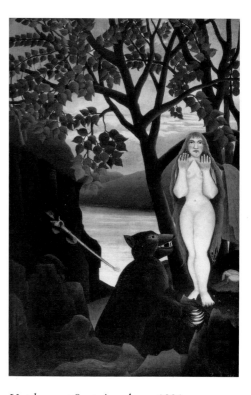

Unpleasant Surprise, about 1901
Mauvaise surprise
Oil on canvas, 194.5 x 129 cm
Merion (Pa.),
The Barnes Foundation

The Snake Charmer, 1907
La Charmeuse de serpents
Oil on canvas, 169 x 189.5 cm
Paris, Musée d'Orsay

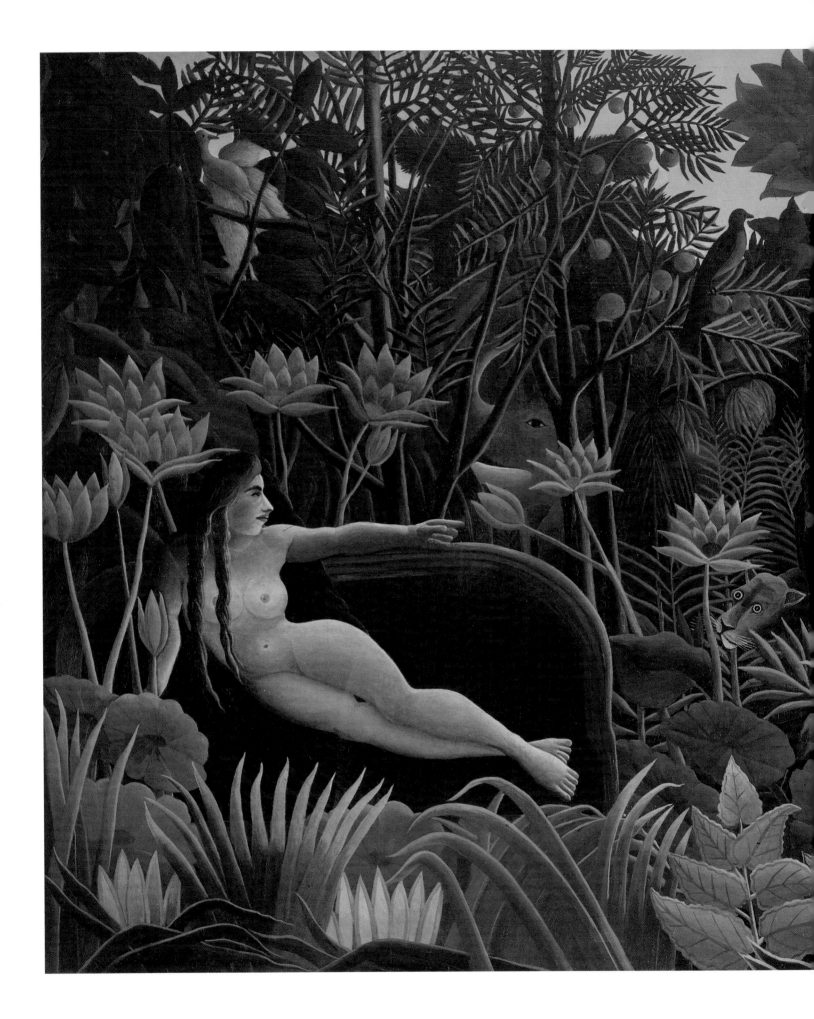

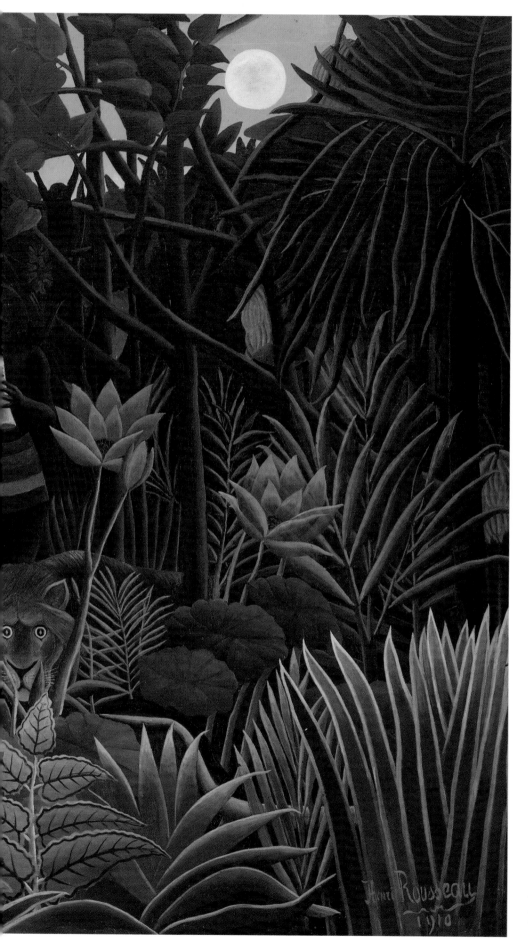

Yadwigha, sleeping peacefully,
In a beautiful dream
Hears the notes of a pipe
Played by a friendly snake charmer.
While the moonlight gleams
On the flowers and verdant trees,
The tawny serpents listen
To the instrument's tuneful airs.

The Dream, 1910
Le rêve
Oil on canvas, 204.5 x 298.5 cm
New York, Collection, The Museum of
Modern Art,
Gift of Nelson A. Rockefeller, 1954

the strict two-dimensionality which other more abstract artists could achieve only at the expense of meaning. Twenty-six versions of the jungle theme can be attributed to Rousseau with confidence. All except *Surprise!* were painted during the short period 1904–1910. Rightly or wrongly surrounded with an aura of mystery and naiveté, the artist had found something on which he could build. He vied with the most accomplished theoreticians, and at the same time he preserved his own territory intact.

Each successive picture shows some further advance in quality of composition and imagination. Cane, oak, eucalyptus, lilac and banana plant, sansevieria, fern, palm, cactus and agave provide unending multiplicity of form. The palette includes fifty different shades of green according to Ardengo Soffici's analysis of the colours in *The Dream* (see pp. 76/77). The characteristic collage style becomes more pronounced, with wild animals and their prey, combat between natives and lions or tigers, hordes of monkeys at play, gleaming orchids, lantern-like oranges, red suns and white moons emblazoned in the green. The fine Gobelin texture of the landscapes suggests labyrinths of increasing density. The minute details of silhouette, trellis, cube and axis prevent the eye from resting on any central focus. Each part of the picture is given equal status, no part subordinated to any other. Disproportionate forms, abrupt changes of colour, backdrops brought into the foreground, all contribute to the complexity of the overall effect. These airless jungle scenes seem to hide more secrets than they reveal. Behind the green lurks bottomless black; blossoms of paradise reflect and veil the cruelty of the jungle.

With such precise definition of every detail the realism of these scenes takes on a structure at once abstract and concrete which was of great interest to the avant-garde that had developed since the time of Seurat. The analysis of outer reality gives rise to pure synthesis in the picture. Rousseau's intuitive discovery of his own method of representing absolute space, a multiplicity of viewpoints in a single plane, ran parallel to the early Cubism of Picasso, Braque and Léger.

The innovatory style of the jungle pictures brought a real breakthrough for the Douanier. In 1905 the Paris Autumn Salon showed the spectacular picture *The Hungry Lion* (see pp. 90/91) with the detailed subtitle: "The Lion being hungry throws itself on to the Antelope and tears it apart. The Panther waits in suspense for the moment when it, too, can have its share. Birds of prey have torn a piece of flesh from the upper part of the poor animal who lets a tear drop down its cheek. Sunset."

Such excesses are said to have moved the critic Louis Vauxcelles to coin the term "Fauve" ("Tawny") for the uncompromisingly modern artists whose works were shown at this exhibition. In its issue of 4th November the journal "L'Illustration" reproduced the exotic landscape alongside works by Henri Matisse, André Derain, Paul Cézanne and Edouard Vuillard. Many admired this "hybrid between terracotta and fresco"; they commended its archaic planar style, compared it to oriental works of antiquity, to Japanese masters and to prehistoric cave painting. The time was ripe for the primitive art which Alfred Jarry and

"I don't know whether you feel the way I do, but when I am in these hothouses and see the strange plants from exotic lands it seems to me that I am entering a dream. I feel like a quite different person."
Henri Rousseau

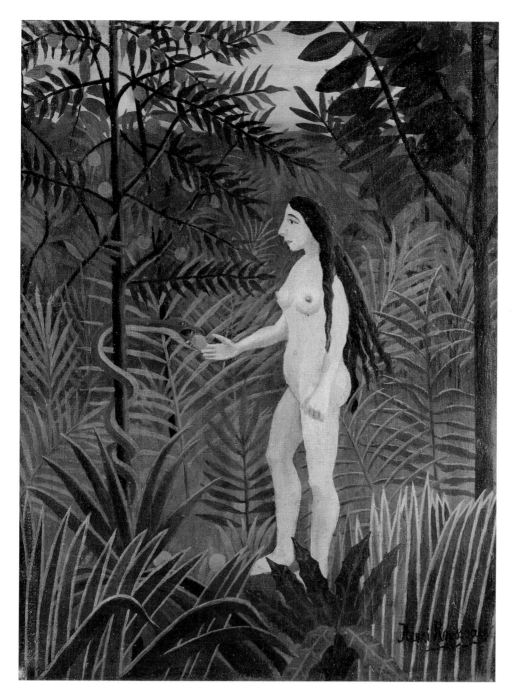

Eve, about 1905–1907
Eve
Oil on canvas, 61 x 46 cm
Hamburg, Hamburger Kunsthalle

Rémy de Gourmont had preached some years before. While Picasso
and Matisse took their bearings from African sculpture, Rousseau could
be acclaimed as the genuine primitive of the age.

He was seen in this light by artists, intellectuals, men of letters and
patrons of the arts. In 1906 Jarry introduced Guillaume Apollinaire and
Rousseau to one another with momentous consequences. In the same
year the young painter Robert Delaunay sought the Douanier's ac-
quaintance, and it was his influential mother, Berthe Comtesse de De-
launay, who commissioned *The Snake Charmer* (see p. 74) in 1907. She
in turn alerted the German art historian and collector, Wilhelm Uhde,
and Matisse's pupil Max Weber to Rousseau's work. There followed
what can only be described as a chain reaction in the most exclusive
Paris circles. The gallery owner Ambroise Vollard, the Russian painter
Serge Jastrebzoff alias Férat and his sister Hélène von Oettingen, who

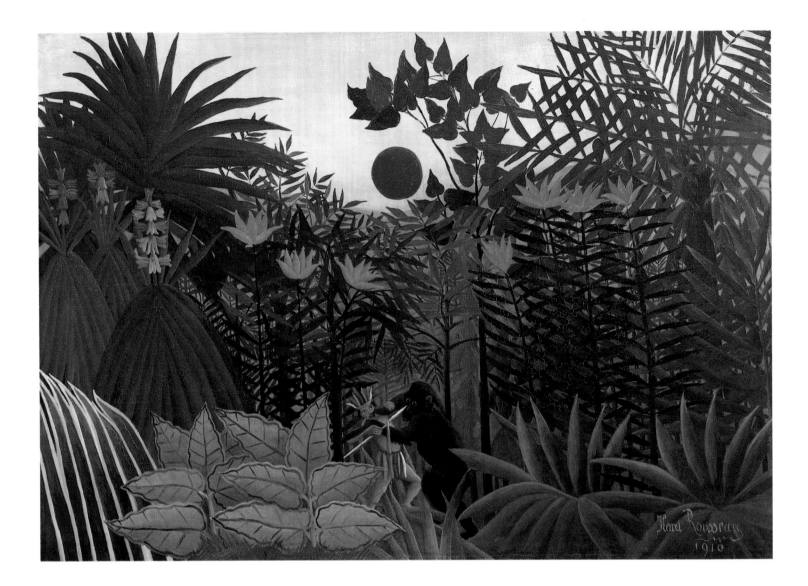

*Exotic Landscape, Fight between Gorilla
and Indian,* 1910
Paysage exotique
Richmond, The Virginia Museum of Fine
Arts, Mr. and Mrs. Paul Mellon
Collection

wrote under the pseudonym of Roch Grey, the sculptor Joseph Brummer, Wilhelm Uhde and Robert Delaunay all bought Rousseau's pictures. He welcomed to the soirées which he gave from 1907 in his studio in the Rue Perrel 2 not only his neighbours and the parents of his pupils but also such luminaries as Guillaume Apollinaire, Marie Laurencin, Francis Picabia, Maurice Utrillo, Constantin Brancusi, Jules Romains and Félix Fénéon.

The Bateau Lavoir banquet of November 1908 that Picasso gave in honour of the Douanier has gone down in history. Round the focal point – the *Portrait of a Woman* that had just been purchased for five francs from a bric-à-brac shop – gathered numerous guests, among them Apollinaire and Marie Laurencin, Fernande Olivier (Picasso's mistress at the time), Max Jacob, George Braque, André Salmon, Maurice Raynal, Léo and Gertrude Stein. For two hours everybody waited for the food that had mistakenly been ordered for the following day. In the event they made do with some fifty bottles of good wine and tinned sardines. Mildly intoxicated and without regard to the candle wax dripping onto his head from a coloured lantern, Rousseau played on his violin the popular strains and original compositions that he performed every year in the Palais Royal for the receptions of the Indépendants.

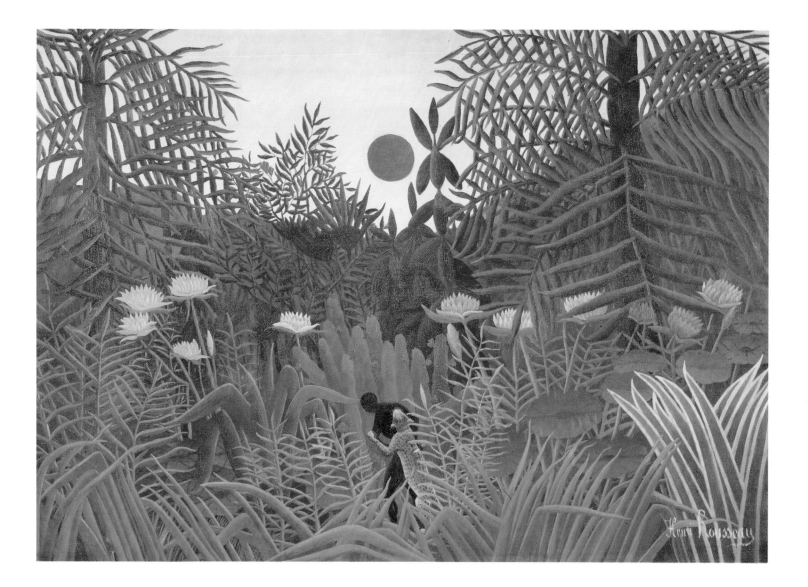

Negro attacked by a Jaguar, 1910
Nègre attaqué par un jaguar
Oil on canvas, 116 x 162.5 cm
Basle, Kunstmuseum

Many stories have been told about this turbulent evening when the bohemians paid homage to Rousseau, who now at last was recognised by society. Special importance must be attached to two incidents which indicate how the hero of the evening wanted to be seen.

On that November evening Rousseau allegedly said to Picasso: "We two are the greatest painters of our time, you in the Egyptian and I in the modern style." Moreover he raised no objection to Apollinaire's improvised poem with the opening verses:

"Do you recall, Rousseau, the land of the Aztecs,
The forests where mango and pineapple grow?
Where monkeys spill the red blood of the Pastecos
And the fair-haired Emperor was harried and slain?
-- Your painting captures what you saw in Mexico -
Red sun in green banana leaves;
Hereafter the brave soldier's uniform, Rousseau,
You changed for the Douanier's upright blue."

In both cases the painter contributed to the fabrication of the legend. In a bizarre way the ambivalence between statement and silence is

Negro attacked by a Jaguar, 1910
(see p. 81), detail

Young Jaguar with Keeper
Photograph
from: Album "Bêtes sauvages",
Galeries Lafayette, about 1900

crammed with truth as well as fiction. He takes traditional models as his starting-point, yet his life and work flout tradition. There is compelling evidence that he was never in Mexico; during the years 1861 to 1867, when French troops were part of the expeditionary force sent to secure the coronation of the Hapsburg Maximilian as Emperor of Mexico, the young Rousseau was first a detainee, and then a volunteer with the home battalion in Angers. Yet he listened eagerly to the stories of returning soldiers and it was with the jungle pictures decades later that he strove for rehabilitation.

His contemporaries, even his first biographer Wilhelm Uhde, were obliged for several reasons to give credence to the myth. For one thing, a cult figure of this sort lends itself to a neo-Romantic interpretation, exhibiting a flight to the exotic in the manner of Gauguin; the primitive can be seen as inhabitant of an earthly paradise. For another, Rousseau is almost obsessive in his attempts to make the jungle world of his imagination come true; he bestows on it a reality which drives out the external world, and with which he even deludes himself. It is said that while painting these green labyrinths he was sometimes so much in the grip of his imagination that he felt stifled and afraid and had to open the window.

The Douanier embarked on the fascinating dreamland journey to the unending chain of experience which links Baudelaire's "Fleurs du mal" with the nineteenth century's yearning for nature and the exotic wilderness. There is ample documentation. In an interview published by Arsène Alexandre in March 1910 he confessed his fondness for the hothouses of the Jardin des Plantes. His figures, however, leave the botanical gardens behind them and wander unprotected through the garden of temptation. On a visit to Rousseau's granddaughter in Cherbourg in 1961 the former music pupil, Yann le Pichon, discovered the album "Bêtes sauvages" that was issued by Galeries Lafayette at the turn of the century. It is clear that the painter drew his animal motifs

and even the figure of the keeper with the young jaguar (see p. 82) from this album, probably with a pantograph, but his jungle picture transforms harmless play into a deadly embrace – the animal throttles the black silhouette (see p. 81).

Here, as so often in the jungle pictures, the predilection for violence suggests hidden turbulence in the artist's character: from a psychological viewpoint Rousseau is not the noble savage inhabiting a tranquil golden age in harmony with nature; rather he is the hard primitive described by Homer and Hesiod. Camouflaged by the Belle Epoque he lives out his individual battle against everyday civilisation and the constraints of his four walls. Untrammeled and irrepressible, he is impervious to convention. The exotic idylls of the Paris World Exhibitions and the lively illustrations of the "Journal des Voyages et des aventures de terre et de mer" or the "Magasin pittoresque" are metamorphosed into phantasmagoria. The wild animal is transposed from the menagerie to freedom. Domesticated tropical landscapes become devouring jungles. Aggression, eroticism and terror are brought into the open. Be-

REPRODUCTION PP. 84/85:
Lion's Repast, 1907
Le repas du lion
Oil on canvas, 113.7 x 160 cm
New York, The Metropolitan Museum
of Art, Sam A. Lewisohn Bequest, 1951

Horse attacked by a Jaguar, 1910
Cheval attaqué par un jaguar
Oil on canvas, 89 x 116 cm
Moscow, Pushkin Museum

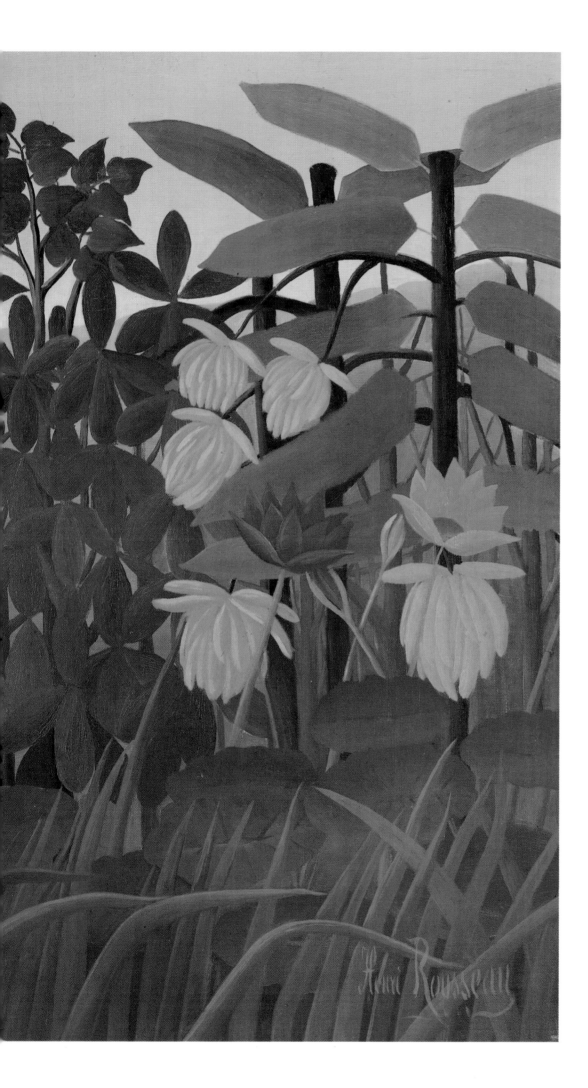

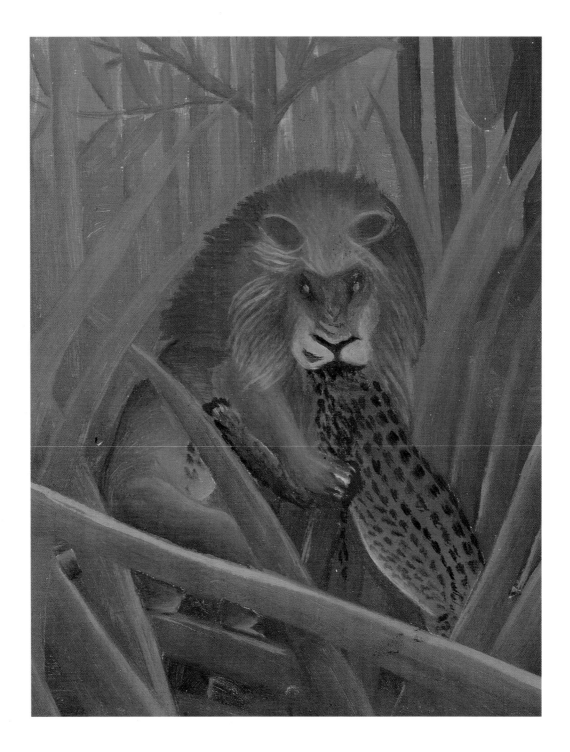

Lion's Repast, 1907
(see pp. 84/85), detail

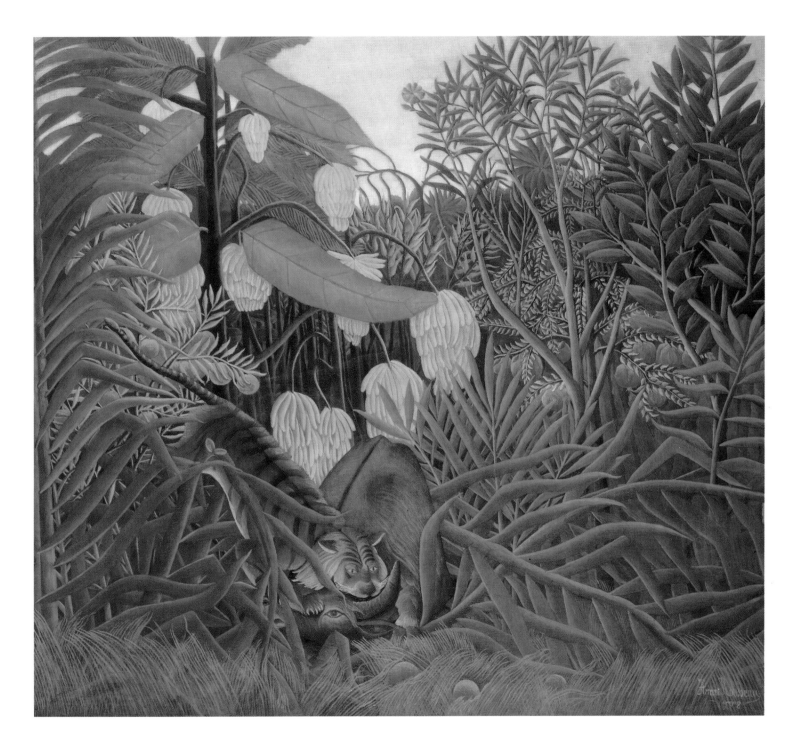

Fight between a Tiger and a Buffalo, 1908
Combat de tigre et de buffle
Oil on canvas, 172 x 191.5 cm
Cleveland, The Cleveland Museum of Art,
Gift of Hanna Fund, 49.186

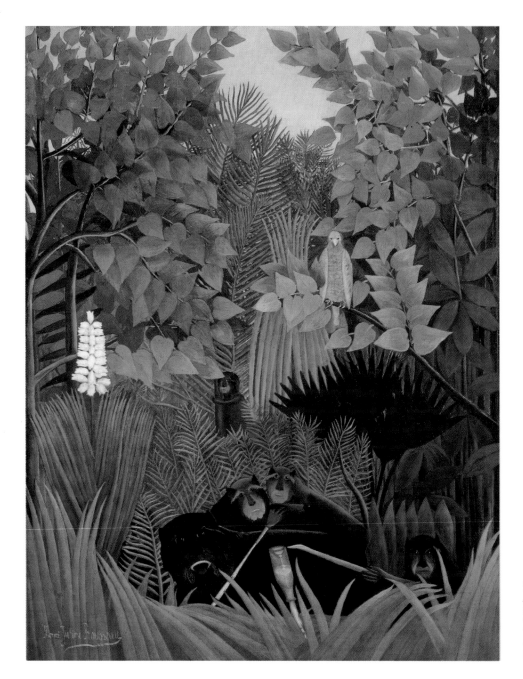

Merry Jesters, about 1906
Joyeux farceurs
Oil on canvas, 145.8 x 113.4 cm
Philadelphia, Philadelphia Museum of
Art, Louise and Walter Arensberg
Collection

hind every leaf is the artist in disguise, balancing on the edge between
fear of death and hope of peace.

A tangled jungle of fantasy and truth surrounds the trial in which
Rousseau was involved from December 1907. Indicted as accomplice to
the chief defendant, the young bank employee Louis Sauvaget, for bank
fraud and forgery, he was condemned in January 1909 to two years sus-
pended prison sentence. The sibylline outcome is veiled in mystery, like
so many pieces of his legendary life. Had he not played the part of a
simpleton, had the press not been well-disposed towards him, had he
not had such influential friends, he might well have ended his days in a
penal colony. Under the name of Bailly he had obtained 21,000 francs
in cash for his partner from the Banque de France in Melun.

Henri Rousseau closed his intriguing career with a renewed affirma-
tion of faith in grand realism. In 1910 he explained his last jungle pic-

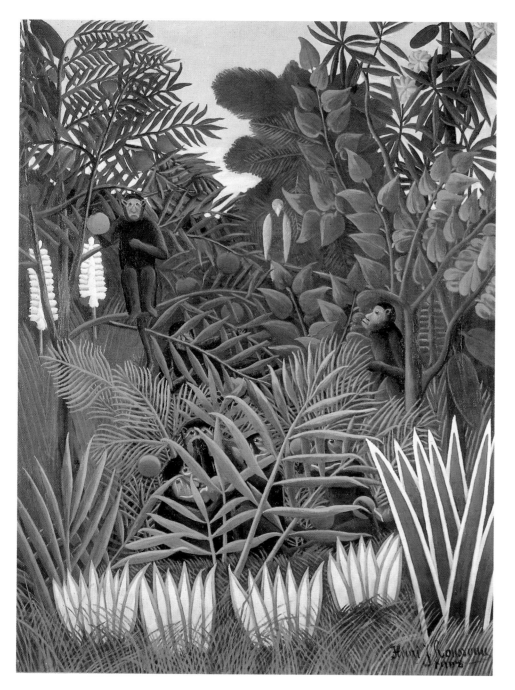

Exotic Landscape, 1908
Paysage exotique
Oil on canvas, 116 x 89 cm
Private collection

ture (see pp. 76/77), and indeed his whole work, to the doubtful critic André Dupont: "The woman who has fallen asleep on the sofa dreams that she has been transported to this forest and is hearing the sounds of the snake charmer's music. That explains the motif of the couch in this picture."

REPRODUCTION PP. 90/91:
The Hungry Lion, 1905
Le lion ayant faim se jette sur l'antilope
Oil on canvas, 201.5 x 301.5 cm
Private collection

An exemplum:
To fête Baby!

About 1903, Oil on canvas, 100 x 81 cm
Winterthur, Kunstmuseum

Rousseau lost four of his children to tuberculosis. About 1903 he painted *To fête Baby!* , one of the loveliest pictures of a child since Philipp Otto Runge. Rounded like a china doll on a turn-of-the-century greetings card, somewhat in the manner of Fernando Botero, the putto in its white chemise stands rooted in the summer meadow with its corn poppies and marguerites. The light half-frame of branches, the verdant foliage, the reddish path, the poplars in the distance – all this breathes a stillness that is given an air of fairyland by the shining leaves and the child's golden hair. The child holds up the front of its chemise full of flowers, and with the other hand it proudly presents to the observer a large marionette whose brightly coloured costume takes up the colours of the flowers. The picture encapsulates the romantic nostalgia of the nineteenth century. When feudalism ended, a myth took over which stylised childhood as the quintessence of innocence and the Golden Age. All those who in the wake of Jean-Jacques Rousseau took "back to

nature" as their slogan demanded also a return to childhood. Rational philosophy was ana-thema to them, they went back to the beginning in their search for wholeness. In his defence of dandyism Barbey d'Aurevilly wrote: "Like the tortoise the poet carries his house on his back, and this house is the very first castle of his dreams." It was poets, artists and aesthetes such as Alfred Jarry, Guillaume Apollinaire, Odilon Redon, Robert Delaunay, Vassily Kandinsky and Wilhelm Uhde, who, weary of traditional school models, established the fame of the Douanier. For all of them Henri Rousseau was the "venerable child" of art, the great primitive who lived and worked beyond the reach of damaging speculation and sophistication, at one with himself, original, as nature had made him. Conscious, deliberate action was seen as a negative ingredient of culture, and Rousseau was quickly acclaimed as the unconscious ar-tist. But was that really the case? *To fête Baby!* seems to be the artist's own testimony with regard to himself. Oneness with na-

ture, safety, security are its themes. The marionette, symbol of mechanisation and alienation, is not yet in control of this unblemished paradise. Perhaps this harlequin with his huge moustache is really Rousseau? A jolly toy in the hands of the child that he still is? It would be a plausible statement on the part of the artist who took refuge throughout his life in a kind of commedia dell'arte, who disguised himself behind Pierrot's mask as early as 1886 and then pleaded exonerating naiveté on various later occasions. With a good measure of self-awareness he wrote to the judge on 6.12.1907, in an attempt to plead innocence in the bank fraud trial: "In all my works people find a remarkable upright quality, which I have endeavoured to sustain in all I have done. It is often said that my heart is too open for my own good. . ." And on 13th December he drew attention to his fundamental honesty: "If by the way I had acted differently I could not have developed the natural intuition which even my parents overlooked."

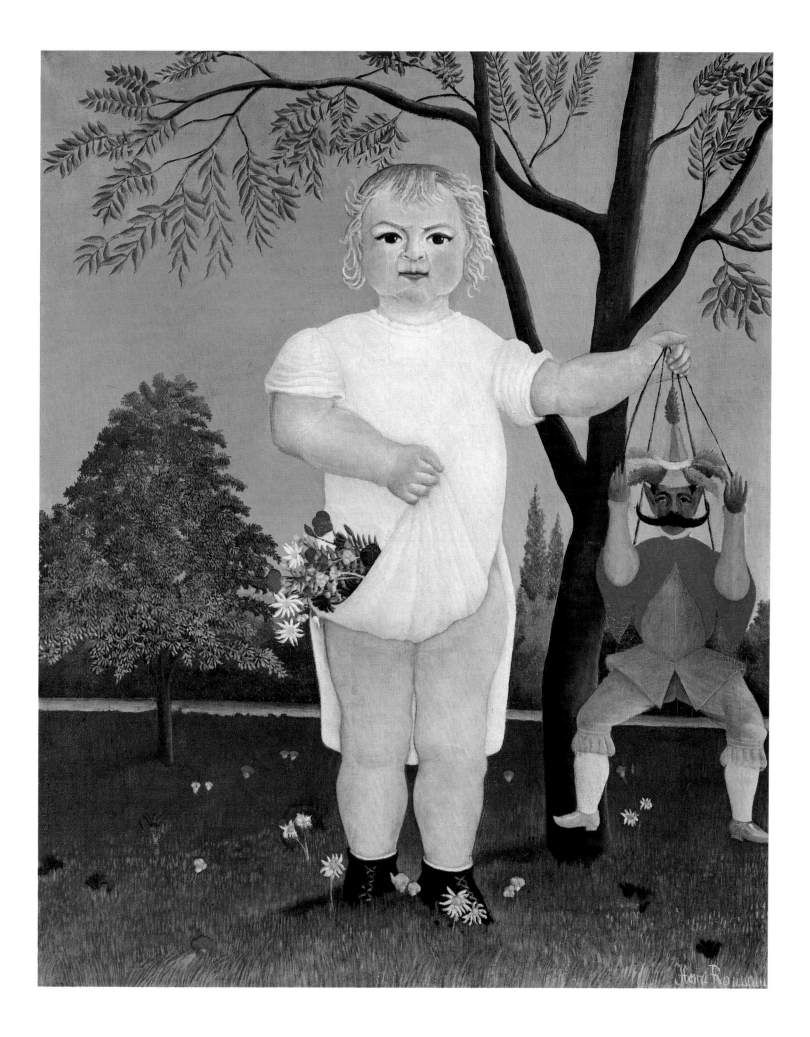

Henri Rousseau: Biographical notes

1844 Henri-Julien-Félix Rousseau born 21 May in Laval (Mayenne) as third child of the tin-ware merchant Julien Rousseau and his wife Eléonore.

1849–1860 Educated at Laval elementary school and lycée; as boarding-pupil from 1851, in consequence of bankruptcy of father's firm and parents' frequent moves.

1861 Family move to Angers.

1863–1867 Employment with the advocate Fillon. Theft of 20 francs, partly in postage stamps, followed by youth detention, one month in Nantes. Voluntary enlistment for seven years in the army, assignment to 51st Infantry Regiment in Angers. No participation in Mexico expedition in spite of subsequent legend to this effect.

1868 Father's death. Early release from army, move to Paris. Lodgings at 25, Rue Rousselet. Employment with bailiff Radez.

1869 Marriage to the 18-year-old seamstress Clémence Boitard. Only one daughter of this marriage, Julia, reached adulthood (died 1956).

1871 Employment, later as permanent civil servant, in Paris toll service.

1872 Possible first attempts at painting.

1884 Copying licence for the Louvre, the Musée de Luxembourg, the palaces of Versailles and Saint-Germain on the recommendation of Félix Clément, winner of the Prix de Rome. Lodgings at 135, Rue de Sèvres.

1885 Two pictures exhibited at the "Salon des Refusés". Diploma of the

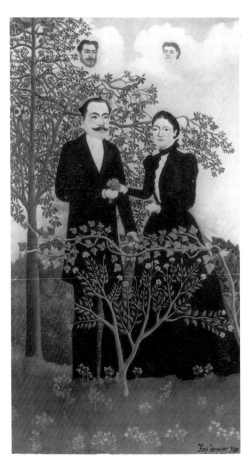

The Present and the Past, 1890 – 1899
Le présent et le passé
Oil on canvas, 84 x 47 cm
Merion (Pa.), Barnes Foundation

"Académie littéraire et musicale de France" awarded for the piece "Clémence, waltz with introduction, for violin or mandoline", performed in the Salle Beethoven.

1886 Four pictures, including the well-known *A Carnival Evening*, shown at the "Salon des Indépendants" on the advice of the painter Maximilien Luce. Pictures regularly shown at the Salon in the following years, except 1899 and 1900. Camille Pissarro among the first to admire them.

1887 Comparisons with early Renaissance painters drawn by Paris art critics.

1888 Clémence Rousseau dies of tuberculosis. Rousseau's works attract the attention of Odilon Redon.

1889 Deep impression made by Paris World Exhibition. "Une visite à l'Exposition de 1889" written (published 1947 by Tristan Tzara).

1890 Paul Gauguin one of the admirers of *Myself. Portrait-Landscape*.

1891 First jungle picture *Surprise!* positively reviewed by the young painter Félix Vallotton.

1892 The allegory *A Centenary of Independence* reviewed by Arsène Alexandre.

1893 Unsuccessful entry for the competition for Bagnolet Town Hall. Leave for early retirement granted.

1894 *War* exhibited. First meeting with poet Alfred Jarry.

1895 Lithograph of *War* published in journal "L'Ymagier" edited by Alfred Jarry and Rémy de Gourmont. Biographical sketch written for the Coutance et Gérard series "Portraits du prochain siècle" (did not appear).

1897 *The Sleeping Gipsy* reviewed by Thadée Natanson in the "Revue blanche". Jarry lodges with Rousseau, 14, Avenue du Maine.

1898 Unsuccessful entry for the competition for the banqueting room

of the Town Hall of Vincennes. Participation in Rosicrucian spiritist séances. Becomes a Freemason. Studio at 3, Rue Vercingétorix.

1899 "La Vengeance d'une orpheline russe" written (published 1947 by Tristan Tzara). Marriage to the widow Joséphine-Rosalie Nourry.

1900 Visits to the Paris World Exhibition and the retrospective "One hundred years of French art". Submission for the competition for the Town Hall of Asnières.

1901 Lodgings at 36, Rue Gassendi. Stationery shop opened by Joséphine, Rousseau's paintings also offered for sale. *Unpleasant Surprise* makes profound impression on Renoir.

1902 Lessons in miniature and china-painting given at the Association Phil-

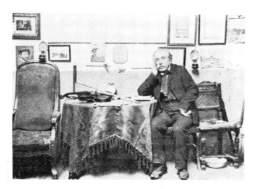

Rousseau in his studio, about 1908

otechnique, an adult education centre. Support for the election campaign of the radical socialist Adolphe Messimy.

1903 Death of Joséphine Rousseau.

1904 The second jungle picture *Scouts attacked by a Tiger* shown.

1905 The sensational *The Hungry Lion* shown at the Salon d'Automne.

1906 First meeting with the painter Robert Delaunay. Introduced by Jarry to the poet Guillaume Apollinaire. Lodgings at 2bis, Rue Perrel.

1907 Jungle picture *The Snake Charmer* painted for Berthe Comtesse de Delaunay, mother of the painter. Introduced by the Comtesse to the German collector and art historian Wilhelm Uhde, the Russian painter Sonia Terk, later Delaunay, the Matisse pupil Max Weber and others. Studio soirées from this time, entertaining among others the most important patrons of the arts, men of letters and avant-garde artists.

1908 Legendary Bateau Lavoir banquet in honour of Rousseau given by Picasso in December.

1909 Sentenced to a 200-francs fine and two years imprisonment (suspended sentence) for bank fraud. Second version of the double portrait of Apollinaire and Marie Laurencin. Works shown by Salon Izdelsky in Kiev and Odessa, one year later in St Petersburg and Riga.

1910 *The Dream* exhibited. Paintings commissioned by Ardengo Soffici, Ambroise Vollard, Serge Férat, Hélène d'Oettingen and others. 2nd September, death from blood-poisoning in the Hôpital Necker. Funeral in Bagneux attended by seven people, among them Paul Signac and Robert Delaunay. Memorial inscription by Apollinaire, engraved 1913 by Brancusi and Ortiz de Zarate (remains transferred to Laval, 1947).

Rousseau in his studio, Rue Perrel, about 1907

Select Bibliography

Alexandre, Arsène, La vie et l'œuvre d'Henri Rousseau, Peintre et ancien employé de l'octroi (Interview), in: Comoedia, 19 March 1910

Alley, Ronald, The Portrait of a Primitive – The Art of Henri Rousseau, Oxford 1978

Apollinaire, Guillaume, Le Douanier, in: Les Soirées de Paris, 20, 15 Jan. 1914

Bihalji-Merin, Oto and L., Henri Rousseau. Leben und Werk, Cologne 1971

Bouret, Jean, Henri Rousseau, Herrsching 1974

Certigny, Henry, La Vérité sur le Douanier Rousseau, Paris 1961

Delaunay, Robert, Mon ami Rousseau, in: Les Lettres françaises, August, Sept. 1952

Eichmann, Ingeborg, Five Sketches by Henri Rousseau, in: Burlington Magazine, 72, 1938, p. 300 ff.

Garçon, Maurice, Le Douanier Rousseau accusé naif (Rousseau's letters to the prosecuting judge), Paris 1953

Grey, Roch, Henri Rousseau, Rome 1922

Kandinsky, Wassily, Über die Formfrage, in: Essays über Kunst und Künstler, ed. Max Bill, Stuttgart 1955, p. 15 ff.

Henri Rousseau exhibition catalogue, The Museum of Modern Art, New York 1985 (Grand Palais, Paris 1984/85)

Le Pichon, Yann, Le Monde du Douanier Rousseau, Paris 1982

Perruchot, Henri, Le Douanier Rousseau, Paris 1957

Rich, Daniel Catton, Henri Rousseau, New York 1942

Rousseau, Henri, La Vengeance d'une Orpheline Russe, Drama in 5 acts, 19 scenes, ed. Cailler, Geneva 1947;

Un Voyage à l'Exposition de 1889, Vaudeville in 3 acts, 10 scenes, ed. Tristan Tzara, Geneva 1947

Salmon, André, Henri Rousseau, Paris 1962

Shattuck, Roger, The Banquet Years, rev. ed. London 1969

Soffici, Ardengo, Henri Rousseau, in: La Voce 1910

Soupault, Philippe, Henri Rousseau, le Douanier, Paris 1927

Stabenow, Cornelia, Die Urwaldbilder des Henri Rousseau, Diss. Munich 1980

Stabenow, Cornelia, Henri Rousseau, Die Dschungelbilder, Munich 1984

Uhde, Wilhelm, Henri Rousseau, Paris 1911 (Düsseldorf 1914)

Vallier, Dora, Henri Rousseau, Cologne 1961

Vallier, Dora, Tout l'œuvre peint de Henri Rousseau, Documentation et catalogue raisonné, Paris 1970

Illustrations

The publishers wish to thank the museums and institutions named in the captions for permitting and facilitating reproductions. Thanks are also due to the following archives and institutions: Archiv für Kunst und Geschichte, Berlin: 89; Bibliothèque Nationale, Paris: 12, 95 top; The Bridgeman Art Library, London: 15, 46, 86; Photographie Giraudon: 20, 25, 38, 39, 40, 52/53, 63 top left, 64/65, 67, 73, 74; Kulturgeschichtliches Bildarchiv Hansmann: 23, 37, 66; Colorphoto Hans Hinz: front cover, 33, 36, 44/45, 60, 72, 79, 81, 90/91, 93; © Réunion des Musées Nationaux, Paris: 24, 55 bottom, 63, 69; Edition Taschen archive: 8, 9, 14, 21, 41, 55 top, 61, 95 bottom; © 1991 The Barnes Foundation, Merion: 75 top.

In this series:

- Arcimboldo
- Bosch
- Botticelli
- Chagall
- Dalí
- Degas
- Delaunay
- Ernst
- Gauguin
- van Gogh
- Grosz
- Hopper
- Kahlo
- Kandinsky
- Klee
- Klimt
- Lempicka
- Lichtenstein
- Macke
- Magritte
- Marc
- Matisse
- Miró
- Monet
- Munch
- Picasso
- Rembrandt
- Renoir
- Rousseau
- Schiele
- Toulouse-Lautrec
- Turner
- Vermeer
- Warhol